A NUTSHELL HISTORY OF
NORTH CAROLINA

A NUTSHELL HISTORY OF

NORTH CAROLINA

BEN FORTSON

THE
History
PRESS

Published by The History Press
Charleston, SC
www.historypress.net

Copyright © 2016 by Ben Fortson
All rights reserved

First published 2016

Manufactured in the United States

ISBN 978.1.46711.928.3

Library of Congress Control Number: 2016934535

For Mrs. Roddey, who shared her passion in the midst of her pain.

For Mae, who graced me with her passion for words.
She is an eloquent saint whose inkwell overflowed love.

For Anne, who was somehow able to champion my awkward scribbles.
Her coaxing and generosity inspired me and made my career shift possible.

For Nancy, who gave me unequivocal trust. Her love and long-stretches of sanity
kept us all going when things got interesting. She deserves a year at the beach.

For North Carolina, whose extravagant beauty, industrious ancestors and
amiable inhabitants furnished a lovely place to live and raise kids.

CONTENTS

CONTENTS

Contents

INTRODUCTION

As a junior in high school, I positioned myself in the last row of Mrs. Roddey's class: World History 101. By the end of the semester, I had maneuvered myself up to the third row and, not to seem too eager, made it to the second row by the spring semester (I assure you it had nothing to with Ann Katherine Ivey, my junior year crush, who sat in the front of the room).

Mrs. Roddey looked to be about eighty years old (she was probably fifty) and taught the entire class from the seat of her knee-length dark dresses. I don't recall any bright colors from her 1975 wardrobe. From her command post, a neatly organized wooden desk, she demanded your full attention with her furrowed countenance and powerful voice. Any shenanigans were met with a "Mrs. Roddey says…," a preamble she always used, followed by strict orders to shape up or ship out. We always shaped up.

Mrs. Roddey had been struck with polio at a young age, and she walked with a decidedly difficult amble, spending most of her nine-hour day at her desk. Throwing all these visceral cues together, from a high schooler's perspective, Mrs. Roddey had all the appeal of a visit to the principal's office—and students who didn't know her kept a watchful eye and a respectful distance. On the other hand, most students who spent more than a week in her history classes—world and American history (I took them all)—came to know a different Mrs. Roddey.

Drawing on my fading memory, the best I can describe it, Mrs. Roddey was magic. When she opened her history book (it must have been different than mine), smiled that southern smile and began to tell one of her stories, her

spell fell over the entire class. Even Jimmy Covington, the high-adrenaline prankster, couldn't resist her alluring tales. We were all doomed. History was suddenly interesting.

Stalin leapt off the page (which was quite scary). Jefferson sat beside me, relating his conflicted life. I hunched around a dying campfire as Daniel Boone recounted his terrifying capture by Indians.

I've been in love with history, and Mrs. Roddey, ever since (my apologies to Ann Katherine Ivey).

This book, in many ways, is an extension of Mrs. Roddey's magic—her spell on one of the thousands of students she taught and loved. And in a magical sort of way, this book is also poignantly connected to her disability. Looking back on her incredible talent (making history come alive for disinterested, hormone-driven teenagers), her passion for students (I later discovered she had no need for income) and her ability to step beyond her impairment, I found strength to attempt the same.

In 2012, after a very active career, I found myself impaired by a disease of the nerves—specifically, peripheral neuropathy—at the time, a meaningless, hard-to-pronounce term (try saying it three times fast) that had begun to impede my mobility. Eventually forced to quit my outdoor job and pursue a sit-down career, I found myself drawn by two former passions: history (thank you Mrs. Roddey) and doodling (thank you Dr. Helms, my long-winded biology professor). Finally settling on the idea of a history comic, I began the awkward, plodding task of drawing a comic strip, creating a website and hoping to drum up interest. My efforts eventually culminated in two comic books (collections of *Almost Off the Record* history comics) and the book you hold in your hand.

This book, *A Nutshell History of North Carolina*, is a culmination of all that Mrs. Roddey exemplified and magically instilled in her pupils. It is an attempt to make history "come alive." And like Mrs. Roddey's history class, it is intentionally stuffed with humor; personal opinions; honest observations; off-the-wall, tangential insights; and a smidgeon of sarcasm—unlike most history books.

I also bring to this literary effort a bit of discombobulated frustration: Why are history textbooks so darn boring? We're talking about real people here; they barfed, tripped, ate French fries and worried about their personal appearance, just like the rest of us.

Addressing this lack of personality, you'll find my book offers a series of illustrations that attempt to highlight the human side of history. They pose important questions like "What if it really happened this way?"; "How

would a five-year-old perceive this event?"; or "What kind of cereal did the Quakers eat?" Naturally, these queries may lead in a humorous direction, but they also shed important, unexpected insights, reminding the reader that understanding history isn't always a deadpan, academic endeavor.

As the name implies, *A Nutshell History of North Carolina* attempts to place North Carolina history into a small shell—a difficult task. More precisely, it is my attempt to give the reader an engaging summary of this enchanting and intriguing state, my home for more than twenty-five years. Written with the hurried historian in mind, my narrative focuses on pivotal events and faces in the history of the Tar Heel State, offering chronological, one-page summaries on over one hundred topics while providing a corresponding human-side illustration with each topic.

Painfully aware that something consequential could be unintentionally omitted from my summary—NC State's Basketball Championship, specifics on the *Duck Decoy Festival* or who named Goat Neck, North Carolina—suffice it to say, I've researched hundreds of sources, read at least twenty accounts of Blackbeard the pirate and referenced my wife on more than one occasion. Hopefully, this has ensured adequate academic rigor. I've done my best to include what most other North Carolina writers have considered historic or at least somewhat interesting.

One final thought before you head out on what I have experienced to be a wonderful and worthwhile journey. As Mrs. Roddey would have appreciated, this is not a "let's pat ourselves on the back" story about my home state. It is one subjective account—as are all historical accounts—taken from the good, bad and disgusting tales passed on by others. I've come across some amazingly brave and daring characters in the course of North Carolina history. On the other hand, there are some flat-out nasty folks who have darkened our pleasant turf. Both must be considered, and both have played a decisive role in making North Carolina, North Carolina. If you hope to wrap your mind around the Tar Heel State—or anywhere, for that matter—then be resigned to ponder the excellent with the unacceptable. It may get ugly, but as they say in Carolina, "Darn if it ain't more interestin' that way."

Enjoy the read. I think you will be pleasantly and frightfully surprised at what you discover about the "Old North State." I sure was.

HOW TO READ THIS BOOK

There is a definite cadence to this seminal work, and understanding its structure will help you navigate its topics and grasp its weighty insights. Each chronological topic in *A Nutshell History* includes a date, title, narrative and illustration. Let's take a quick look at each of these areas.

At the top of each left-hand page, you will find a date. Each date represents a specific year in which a particular topic occurred. It may be the exact year of a Civil War battle, the year a famous politician was born or a general time frame for a series of related events.

Adjacent to the date, you will find a title. Each title refers to a specific topic that will be discussed. The topic may be broad or very specific, but it denotes an event or person(s) who is paramount to understanding North Carolina.

Below the title you will find a narrative* about the topic. The narrative will attempt to describe the relevance of the topic to the history of North Carolina. Often, the narrative will include a story, some fascinating facts and a bit of commentary. Due to the necessity of limiting each narrative to one page of text, you will find abbreviations in vast quantities. I will often denote North Carolina as simply "NC." Likewise, you will find VA (Virginia), GA (Georgia), et cetera, in use. I have also included a glossary to expound on topics that might require further explanation. You will find these terms in bold print and referenced at the end of the book.

Finally, adjacent to the narrative, on the right-hand side of the page, you will find an illustration. Each illustration is designed to provide a whimsical, "what if" perspective on our story and perhaps fill in more

details about the topic. Although it will be tempting to view the illustrations before reading the narrative, I beg of you not to succumb. The narrative will bring meaning—and perhaps a nuanced humor—to the illustration that would be otherwise missing. That is to say, there is a good chance you will have no freaking clue what the illustration is about unless you read the narrative first (I must admit, when reading any book, I always look at the pictures first—but you must seek to avoid my childish behavior).

Now…enough of the how-to's! Saddle up. It's time to explore North Carolina!

* You may be embarrassed to find that people with a certain color of skin are referred to in this book as black, Negro, African American, Indian, Native American, First Nation, white, Caucasian or redneck. I simply used—or quoted—the language of the time. No racial offense is intended.

A NUTSHELL HISTORY
OF NORTH CAROLINA

N

W E

S

MT. AIRY •

• BOONE

• WILKESBORO

GRANDFATHER
MOUNTAIN ★

WINSTON-SALEM •

MT. MITCHELL
★

HIGH POINT •

GREAT SMOKY
MOUNTAINS
NATIONAL PARK

SHELTON
LAUREL •

STATESVILLE •

• LEXINGTON

CLINGMANS
DOME ★

★

ASHEVILLE •

MORGANTON •

CHEROKEE
RESERVATION

• WAYNESVILLE

★ BILTMORE HOUSE

★ CRADLE OF FORESTRY

HENDERSONVILLE •

BILLY GRAHAM
BIRTHPLACE ★

• CONCORD

REED GOLD
★ MINE

• MURPHY

• FRANKLIN

CHARLOTTE •

JAMES POLK ★
BIRTHPLACE

• MONROE

ANDREW JACKSON
BIRTHPLACE? ★

Mountains

Piedmont

Coastal

• City

★ Point of Interest

New River

Yadkin River

French Broad River

Catawba River

Pee Dee River

Tuckasegee
River

Broad River

Hiwassee River

Little Tennessee
River

NORTH

EDEN

ROXBORO

HALIFAX ELIZABETH CITY •

Chowan River

KILL DEVIL
HILLS

EDENTON •

Albemarle Sound

BATTLE OF GUILFORD
★ COURTHOUSE

• GREENSBORO

HILLSBOROUGH •
CHAPEL HILL

• DURHAM
★ RTP

ROANOKE ISLAND •

Tar River

Roanoke River

TARBORO

• ASHEBORO

★ RALEIGH

ANDREW JOHNSON
BIRTHPLACE

• WILSON

• GREENVILLE

• SMITHFIELD • BATH

BATTLE OF
BENTONVILLE

• GOLDSBORO

★

Pamlico Sound

FORT
BRAGG

Neuse River

AVON •
CROATAN ISLAND •
(HATTERAS)

★

• FAYETTEVILLE

NEW BERN •

OCRACOKE

• ROCKINGHAM

HAVELOCK •

Cape Fear River

JACKSONVILLE • BEAUFORT •

• LAURINBURG

• PEMBROKE
• LUMBERTON

CAPE LOOKOUT

★ BATTLE OF
MOORE'S CREEK

WILMINGTON •

★ FORT JOHNSON

CAROLINA

1 BILLION BC: WATERED DOWN

Our story begins many, many years ago—maybe a billion. At this early date, things were reasonably slow in North Carolina—at least above water. No voices echoed across the mountains, no tall timbers swayed in the breeze, no bears roamed the motherland and no hurricanes tore the charming beaches to smithereens. In fact, to be absolutely truthful, the whole place was a dive.

A billion years ago, according to extremely fanatical guessers (scientists), North Carolina was an immense flat plain blanketed by a devilishly warm sea. It was the kind of place big-game fishermen, deep-sea divers and marine scientists would have adored. Your grandmother? Not so much. You see, according to the fossil record, it was inhabited by crazy-looking corals, funky jelly fish, giant eat-anything sharks and larger-than-we-can-imagine sea creatures. These marine animals were fantastic in size, shape and color—with names like pteridinium and megalodon—and they spread themselves across the entire water-soaked state.

But there was one problem. These dazzling creatures had no idea they were in North Carolina.

250 Million BC: Land Ho!

As the years passed by—probably a few million—our lovely marine beasts were still unaware of their whereabouts. Unbeknownst to them, they were splashing around the future site of a most unusual state, one that would boast hidden treasures, hordes of Indians, throngs of pirates, legions of explorers, piles of innovators, heaps of barbecue and a plethora of quilts.

By now, it didn't really matter if they were unable to pinpoint their GPS coordinates, for these strange sea creatures had begun to ship out. You see, the devilishly warm waters had begun to recede. Massive geologic forces were forming epic mountains, gaping valleys and raging rivers. North Carolina was emerging from the muck...and things were starting to get interesting.

The Appalachian Mountains—eons ago the highest mountains in North America—were forming along the western boundary of the future state. Running northeasterly, they would eventually form the sub-range Blue Ridge Mountains and Great Smoky Mountains and extend themselves all the way to Canada—an expansive bulge that ran for over 1,500 miles and, at its widest point, left a 300-mile-wide zone of sub-ridges and foothills.

The dinosaurs that moved into the area were completely amazed at these new developments.

60 MILLION BC: MAMMAL TIME

After another long while, seeing the diversity of plants and animals available for consumption and recognizing that North Carolina was undoubtedly a nifty place to live, mammals began moving in. These mammals included bison; huge pigs; grizzly bears; a wide variety of antelope and elk; large, predatory cats; gigantic sloths; and wooly mammoths. The variety of animal life would boggle the modern-day mind.

By this time, North Carolina had developed into three distinct geographic regions: the Appalachian Mountains, the Piedmont (also called the Foothills) and the Coastal Plains. These regions, and the plants and animals that thrived there, would play a pivotal role in the dispersal of humans across the state.

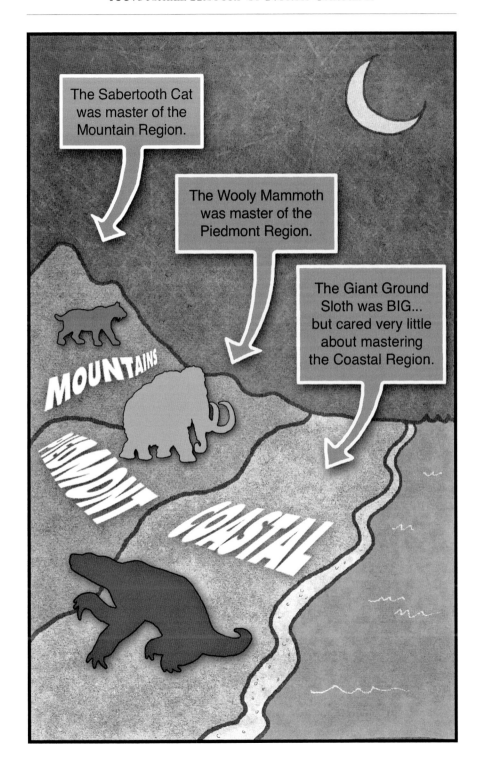

10,000 BC: First Americans

Several years later—we're talking quite a few—North Carolina was introduced to its first humans. Making their way from the land of Siberia into North America and then spreading east across the continent, these humans came to be known as Native Americans (or Indians, as Columbus liked to called them).

The Native Americans of North Carolina were adept at hunting and fishing, gathering existing edibles or creating their own food by means of farming. These early Carolinians developed a culture dependent on small, tightknit groups working together to secure their necessaries. Unfortunately, none of these Native Americans wrote down their history—the story of their life in North Carolina—so most of their story is unknown.

Of one thing we are certain: they lived here a very long time, much longer than the Europeans who would eventually arrive thousands of years later.

1000 BC: Tribes

Over the course of centuries, many more Native Americans moved into North Carolina. By now, these Indians had developed their own unique languages, territories and culture. Those groups who shared similar traits began to align themselves into specific tribes. Before the arrival of Europeans, Native Americans populating North Carolina had combined into three major language groups: Iroquoian, Siouan and Algonquian. The two most prominent Iroquoian tribes were the Cherokee and the Tuscarora. The main Siouan tribes consisted of the Catawba, Cheraw, Waxhaw and Waccamaw. The larger Algonquian tribes were the Chowanoke, Croatan, Pamlico and Roanoke. Although there were many other tribes inhabiting North Carolina, these tribes were the largest and most influential.

Of course, we'd like to imagine that all the tribes of North Carolina were great friends, but we know that by the time the Europeans arrived, tribal conflicts were routine and expected. Like an annual football season, these conflicts were often part of tribal economics and manly, warrior pride. It was not uncommon for tribes to take lengthy forays into rival territories, collecting hides or stealing women from competing Indians.

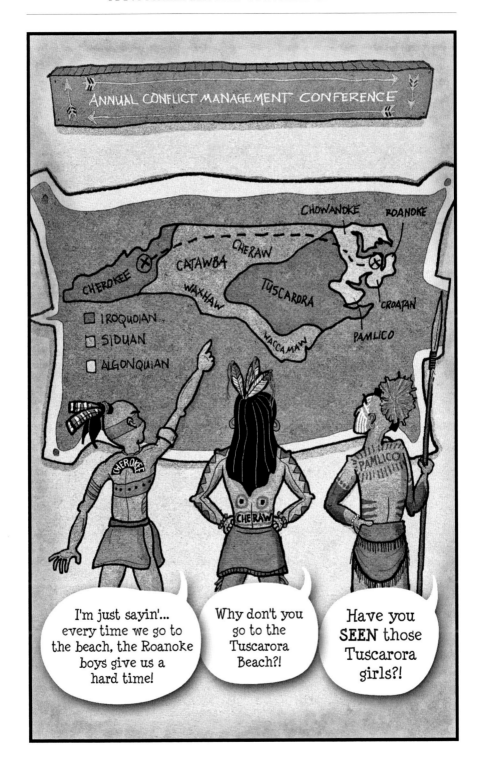

1540: DE SOTO

Now the plot thickens.

According to written records, the first Europeans to arrive in North Carolina were Spanish explorers. These explorers brought with them an entirely different culture, one very strange to Native Americans. Spaniards dressed in sparkling fabrics; spoke in a peculiar romantic language ("Me gusta Carolina del Norte"); rode massive, muscle-bound animals (Native Americans had never seen a horse); utilized magical tools (guns and metal spoons); and possessed very different values ("Give me the shiny rock or I will kill you"). Led by Hernando De Soto, these white visitors passed through present-day Florida, Georgia and South Carolina, eventually wandering through the Appalachian Mountains of North Carolina in search of gold and a trade route to China.

Along with routinely finding no gold or Chinese, De Soto and his band of Spaniards made a habit of antagonizing the local populace—stealing food, enslaving captives and demoralizing the Native Americans with European diseases. He was not well remembered among native North Carolinians, particularly the Cherokee.

Continuing west on his fruitless journey, De Soto died of a fever on the banks of the Mississippi River.

1568: JUAN PARDO

Captain Juan Pardo was the next Spaniard to visit North Carolina. Seeking to claim lands for Spanish settlement and to navigate a route to Mexico, he established a small fort near present-day Morganton. Continuing westward, Pardo built five more forts along the way, then returned to his base on the South Carolina coast.

Native Americans remembered De Soto, and they were not particularly impressed with Captain Pardo. They soon realized that he was not visiting their territory to win friends and influence people. He had other goals in mind—goals that might even involve their enslavement. Within a year, Native Americans had destroyed the forts and killed all but 1 of the 120 men stationed in them. A pattern of mistreatment (by Europeans) and revenge (by Indians) was beginning to take shape in early America. This pattern—we'll call it the Euro-Indie Disorder—would intensify and repeat itself hundreds of times over the next three centuries.

After his unproductive fort-building experiment, Pardo—and the Spanish—never returned to the interior of North Carolina. It would be seventeen years before another group of Europeans would pay a visit.

1587: THE "HEY, WE'RE OVER HERE" COLONY

Not be be outdone, the English finally decided to give North Carolina a go.

Arriving in 1585, the first English colonists built a small fort on Roanoke Island (formerly a part of the Virginia Colony) and attempted to settle in. Running out of supplies and struggling to feed themselves, the colonists befriended the Roanoke Indians and began to rely heavily on their food sources. In an effort to assert their authority (as the Spanish had so aptly attempted), the colonists attacked the Roanoke, killed their chief and tried to subdue his loyal tribesman. Their peculiar strategy ruined their relationship with the Roanoke (invoking the Euro-Indie Disorder) and likewise ruined any chances of securing more food. They soon abandoned their new settlement and returned to England.

Sir Walter Raleigh, a wealthy English entrepreneur, sent another group of settlers to try again in 1587. Unfortunately, they chose the same island with the same neighbors. Once again, struggling to survive, the 117 colonists decided to send a small group back home, for—you guessed it—more supplies. Before departure, John White (the leader of the rescue team) arranged for a means of "texting." If the settlers decided to move to a friendlier neighborhood, they would leave a message carved into a tree, telling of their whereabouts. Suggesting he would return in six months, White departed.

Three years later, due to transportation complications, White returned on his "rescue" mission. Unsurprisingly, he found the island deserted, with only the word "CROATOAN" carved into a tree. Although misspelled, the word referred to a nearby island named after the friendly Algonquian tribe that lived there. Sixty-five miles south of Roanoke, it was surely the place where they had relocated. White attempted to reach the island, but the weather became nasty and the ship's captain felt it was too dangerous to continue. After only one day's effort to reach Croatan, White returned to England (a 3,686-mile journey) empty-handed—and the colonists were never seen or heard from again.

Sadly, White's failed (and lame) rescue would doom the colonists to obscurity. Today, historians often call this first English settlement the Lost Colony. More correctly, it should have been christened the "Hey, We're Over Here!" Colony. The settlers didn't appear to be lost—no one bothered to look for them at their new address. It would be 114 years before an explorer actually visited Croatan Island to inquire about the colonists. They were long gone.

What **really** happened to the "Lost" Colony?
There are six plausible theories
common among historians.

1 Moved to Croatan and became part of the tribe

2 Traveled north to the Chesapeake Bay area, where they were massacred by Indians

3 Died from starvation and disease

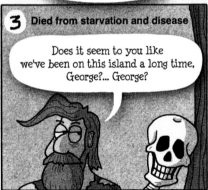

4 Became zombies and spooked the Indians

5 Started a "We Don't Love John White" Club, then moved to Florida

6 Moved to the mainland and opened a Survival Store

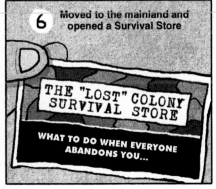

1587: First Birth

A few days before leaving Roanoke Island for supplies, John White's daughter had given birth to a child. The date was August 18, 1587, and the proud parents—Ananias and Eleanor Dare—named their beautiful daughter Virginia Dare in honor of what was then the Colony of Virginia. Eleanor had arrived in the New World only twenty-eight days earlier, supported by a hearty assortment of sixteen women, another of whom was pregnant. Virginia Dare would be the first English-born child in America, and ironically, she, along with her parents, would be abandoned on its shores. In a second turn of bad luck, the colony she was named after would eventually become part of North Carolina, making Carolina, not Virginia, the official bearer of America's first English child.

When John White failed to locate the Roanoke Colony upon his return three years later, the fate of his granddaughter would be seared into the hearts of romantic historians for the next five hundred years and beyond. One would be hard-pressed to find a better, more sadly mysterious tale of firstborns. So rich is her story that hundreds of nauseatingly sentimental accounts have been written about the possible, less-than-plausible outcomes of North Carolina's first citizen, Virginia Dare.

1653: First Resident

After the Roanoke debacle, attempts to colonize the southern coast of Virginia (soon to be North Carolina) came to a screeching halt. Seafaring folks finally realized that this particular part of the North American coastline was somewhat disagreeable (see "The Graveyard of the Atlantic"). Meanwhile, the Chesapeake Bay area of Virginia, about 130 miles north of Roanoke, had been deemed a more suitable harbor.

By 1624, the colony of Jamestown (located along the Chesapeake Bay) had been firmly established, and over six thousand English settlers had made the journey to North America. Owing to the number of arrivals, as well as the improved living conditions, the colony of Virginia began to expand exponentially. Simultaneously, available land (land not occupied by Native Americans) was becoming scarcer. As the British government began exerting more control over the developing colony, local governments were also formed and property taxes were eventually imposed. Add all of this up—overcrowding, plus lack of land, plus property taxes—and you have a math formula for populating North Carolina!

By the 1650s, Virginians who wanted large tracts of tax-free land began moving south into a region now called Albemarle Sound. Unable to manage lands that were so far removed from centers of government, this coastal region slowly became populated by runaway slaves, debtors, criminals and, of course, settlers who didn't want to pay taxes. This new area of settlement would eventually become North Carolina.

In 1653, history records show that the first permanent white resident of Albemarle Sound—and therefore, the first permanent white resident of North Carolina—was a fur trader by the name of Nathaniel Batts. Batts established a trading post and, on an uncharacteristic Anglo-Saxon whim, opted to develop a long-standing friendly relationship with the surrounding Indians—and the incoming riffraff.

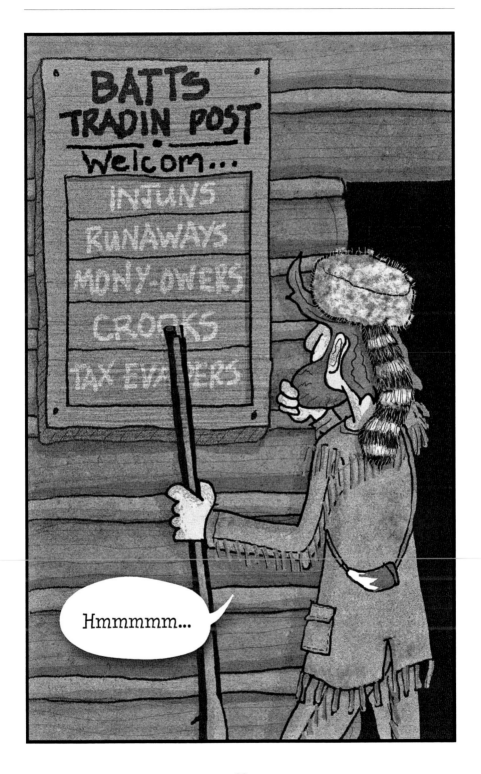

1663: The Charter of Carolina

By 1663, over five hundred white settlers had moved into the Albemarle Sound region. In a bid to tax these unsuspecting individuals, the Virginia Colony had begun the process of trying to establish a local government in the area—but the newly crowned king of England had different ideas.

Charles II had recently returned to power. His father, Charles I, had been beheaded during an ugly English civil war, and Charles II had escaped to France. Oliver Cromwell, a military and political leader, had taken over the British government and ruled as lord protector for five years. Upon Cromwell's death, a political vacuum suddenly materialized. In 1660, due to a remarkably bizarre chain of events, a thirty-year-old Charles II was invited to return to the throne. He promptly accepted.

Keen on rewarding his loyal financial supporters during his royal exile, the cash-strapped Charles II determined to give away a chunk of the American continent. Naming the region Carolina, derived from *Carolus* (the Latin equivalent of Charles), the king appointed eight Lord Proprietors as owners of a tract of land that theoretically included modern-day North Carolina, South Carolina, Georgia, northern Florida, Tennessee, Mississippi, Alabama, Louisiana, Arkansas, Oklahoma, a good piece of Texas, New Mexico, Arizona, the lower tip of Nevada and Southern California. Essentially, the king's land grant included everything south of the Virginia Colony, running coast to coast, with the exclusion of Spanish-claimed Florida and southern Texas.

Adding up to a total of over one million square miles, some considered it an extravagant gift. Charles's handout, known as the Charter of Carolina, named the eight men as owners and rulers of Carolina. The Carolina Colony had been born!

Curiously, the three million or so Indians living in Carolina failed to receive the good news.

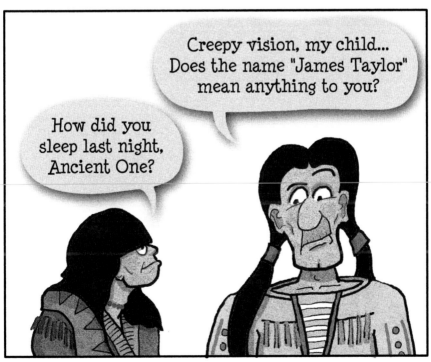

1669: FUNDAMENTAL CONSTITUTIONS OF CAROLINA

The Lord Proprietors of Carolina were given the ability to pass laws, sell land, establish towns, raise armies and make war. Most conveniently, they were awarded the power to tax their subjects—to charge fees on landownership and exported goods. They planned on making a shipload of money.

To create the necessary infrastructure to accomplish these monetary goals, the Proprietors established a number of rules to govern their new colony. Their rulebook, *The Fundamental Constitutions of Carolina*, consisted of 120 paragraphs, written in plain—and confusing—English legalese. The *Constitutions* included conventional British directives, promoting an elite aristocracy, laying out the necessary foundations for **feudal serfdom** and providing for the ownership of one person by another (known in some circles as slavery). The *Constitutions* allowed for an elected legislature (called the Assembly), but only men who owned land could vote. On a more progressive note, though the Church of England was designated as the official church of Carolina (and was supported by tax dollars), dissenters or nonreligious men could vote and hold office. This compensation was particularly tolerant for its day and would prove useful to the **Quakers** in the coming years.

Despite the best intentions of the Lord Proprietors, implementing the *Fundamental Constitutions* did not progress well. It seems the runaway slaves, debtors, criminals and tax evaders occupying Albemarle Sound did not fully appreciate, or understand, the new laws. In less than eight years, relations between the Lord Proprietors and the rogues who settled Carolina would disintegrate into open rebellion—reflecting a fundamental sentiment of the young Carolinians: "Don't mess with us."

1670: TOBAH

As the Carolina Colony grew, so did the number of small farms. In order to survive in the New World, farmers realized they needed to produce a commodity that could be exported back home to England—preferably something that could turn a nice profit. During the Roanoke experiment, Sir Walter Raleigh's colonists had found the Native Americans smoking an interesting weed, referring to it as *tobah*. Tobacco, as we call it today, was widely used by Native Americans and was believed to possess a number of spiritual and psychological benefits, including, but not limited to, a heightened sense of awareness, a feeling of euphoria, a cooperative attitude and a false sense of being more attractive.

Sir Walter introduced the first tobacco to Europe, where it quickly became popular. Referred to in the colonies as Brown Gold, by 1670 tobacco was in high demand throughout Europe and had become the main export for the young Carolina Colony, where tobacco grew prolifically. With the rising interest in chewing, spitting and smoking tobacco, the small farmer realized a substantial profit for his labors. Over the next three hundred years, tobacco would play a leading role in the economy and culture of North Carolina (see "The Tobacco State")—producing yellow teeth and bad breath for a multitude of rapturously misinformed tobacco users.

1677: Culpepper's Rebellion

Due to the treacherous waters off the Carolina coast, tobacco was more easily shipped north on small ships to the colonists in New England, who then shipped it via larger ships to England. This "extra step" (shipping north and then shipping to Europe), combined with the Plantation Duty (a tax on any tobacco not shipped directly to England), placed an added financial burden on the farmers of Albemarle.

The newly appointed governor of the Carolinas, John Jenkins, knowing the hindrance that the new tax placed on his colonists, decided not to enforce it—a smart move for pleasing his neighbors but a bad move for keeping the Proprietors happy. Upon discovering his deceit, the eight Lords (a-leaping) promptly replaced Jenkins with a new governor (Eastchurch) and a new tax collector (Miller). When Eastchurch was delayed in England, Miller appointed himself interim governor and began gleefully collecting taxes while imprisoning all those who opposed him.

In 1677, John Culpepper led a group of forty civilians in armed response to Miller's law-enforcing enthusiasm. Arresting Miller and his officials, Culpepper's rebels took over the government, claiming that Miller had overstepped his authority as "temporary governor." Once word reached England, the Proprietors worried that all this bothersome trouble would cause them to lose their charter. In a surprising reversal of justice, Culpepper and his accomplices were acquitted by the courts of England. Claiming that their "riot" was justified, Lord Shaftesbury (one of the Proprietors) defended the rebellion, arguing that the colonists had every right to rebel against Miller's tax-collecting extremes. Lord Shaftesbury's support of the rebels reinforced a deep-rooted colonial resentment of British interference—and the seeds of self-government were sown.

Following Culpepper's Rebellion, as it came to be known, the Proprietors promptly appointed another governor—and incorrectly supposed that the rebellious colony would eventually settle down.

1700: John Lawson

In 1700, an adventurer by the name of John Lawson was hired by the Lord Proprietors to conduct a survey of the unknown and foreboding wilderness of the Carolina Colony. Setting out with a party of five Englishmen and several Indian guides, Lawson left the port of Charleston, South Carolina, and headed northwest. His journey took him by the future cities of Columbia, Camden and Rock Hill, South Carolina. Continuing north and then east, Lawson traveled by present-day Charlotte, Salisbury, Burlington, Raleigh and Goldsboro, finally ending his adventure in what would become the small town of Bath, North Carolina. The expedition lasted fifty-nine days and covered over five hundred miles.

Lawson recorded a wealth of information along the way—including details about terrain, flora and fauna, water sources and Indian tribes. He would eventually sail back to England and publish a book, *A New Voyage to Carolina*, about his explorations. The book contained 258 pages of his extensive notes on Carolina and was the only book ever produced by the proprietary colony (that is to say, the only book written about North Carolina while the Lord Proprietors were owners of the colony).

Lawson's book generated enthusiasm for the new colony and gave him a distinguished notoriety in Europe. Encouraged by the Proprietors, he recruited both Swiss and German emigrants to seek a new home in Carolina. Lawson would eventually co-found the Swiss/German town of New Bern (1710), but further efforts to explore and colonize Carolina ended in disaster. For his expansionistic efforts, the Tuscarora Indians burned Lawson alive. Lawson became the first casualty in a gruesome two-year war brought on by the injustices of white settlers against the Tuscarora (see "Tuscarora War").

Lawson's friendly demeanor and impeccable
honesty did not, on some occasions,
serve him well.

1705: First Incorporated Town

As settlers continued to infiltrate the Carolina Colony, a small community arose along the coastal junction of Bath Creek and the Pamlico River—a perfect intersection for trade with ships from the Atlantic and for inland trade with the Indians. Originally settled by French Huguenots who had migrated from Virginia in the 1690s, the young town of Bath specialized in **naval stores**, fur trade and tobacco export. John Lawson purchased land there and, by 1705, helped to create the first incorporated town in Carolina. As an incorporated town, with elected officials and stuff to vote on, Bath Town, as it was originally titled, boasted twelve houses and almost fifty residents. It would become home to the oldest surviving church in North Carolina, the first shipyard, the first courthouse and the first public library in the state.

Although remaining sufficiently teeny to warrant a dull existence, the town of Bath would astonishingly claim ownership to political rivalries, Indian wars, epidemics, religious conflicts and piracy. Not bad for North Carolina's first official town!

1710: CAROLINAS DIVIDED

From the colony's inception, the Lord Proprietors recognized that the Carolina Colony wouldn't be easily governed or taxed. For one thing, it was an enormous piece of real estate. For another thing, a very independent lot of nonconformists were trying to occupy the territory. And finally, most intriguingly, the Proprietors didn't really own the land—they were taking it from the Native Americans. Factor in eighteenth-century modes of transportation and communication (they stunk), and the Proprietors were well aware that developing good government would be essential to profitability.

By 1691, the Proprietors had appointed a governor for all of Carolina (he lived in the southern portion of the colony) and a deputy governor (sort of a junior governor) for its northern half. In 1710, in the midst of growing turmoil and the need for more rigorous, income-producing supervision, the Proprietors opted to officially divide Carolina in half. Edmond Hyde, himself a Proprietor, became governor of North Carolina,* and Robert Gibbes was elected governor of South Carolina. Theoretically, this new dichotomous arrangement would allow for better administration of the uncooperative mega-colony.

Both first governors would find their terms abruptly cut short. In 1712, after serving less than two years, Hyde succumbed to yellow fever. Meanwhile Gibbes's term officially ended in 1711 for less terminal yet serious causes. Gibbes had bribed one of his associates to cast a vote for him during the Assembly election. Eventually ratted out, he would unceremoniously lose his position, although it took the Proprietors another year to replace him.

North and South Carolina were off to a gloriously shabby start.

*North Carolina was referred to as the "Old North State," a phrase often used in reference to its being north of South Carolina. The popular, warmhearted phrase was eventually utilized as the title of the official state song, written in 1835 and adopted in 1927 by the General Assembly.

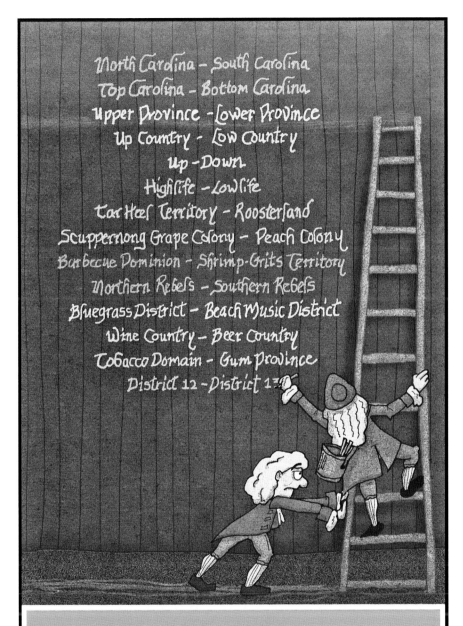

Led by Lord Fruitcake, the Proprietors
engaged in a prolific *Brainstorming Session*,
in hopes of generating winsome titles for
the two new colonies.

1711: THE QUAKERS AND CARY'S REBELLION

With the Carolinas now divided, new leadership became essential. Now our story turns religious.

Founded in the 1600s by George Fox, the Quakers fled England and the persecution of the state-supported Anglican Church. Arriving in the Puritan-dominated Massachusetts Colony, they soon found they were unwelcome there as well. By the late 1600s, the Quakers had discovered a colony that had no religion: North Carolina! Although the Anglican Church had been designated as the official church of the Carolina Colony, no one had bothered to build one. Hearing these glad tidings, the Quakers eagerly settled in the balmy, religion-vacant Carolina Colony.

Although most newcomers to Carolina valued their privacy (and tax-free land), Quakers thrived in tightknit communities. With common goals and interests, Quakers found it natural to build towns, develop schools, get involved in the growth of their communities and step up to political leadership. These highly social Quakers established the first organized church in North Carolina, and by the early 1700s, they dominated as elected officials.

A Quaker's approach to life and community was a boon to Carolina's early well-being. Typically hardworking, peace-loving and decent folk, the Quakers sought to maintain harmony with Native Americans, opposed slavery and strove for equality among citizens. They brought a much-needed time of soul searching and character building for the young colony. But alas, it was not to last.

Unfortunately for NC, and the Quakers who lived there, Quaker influence bothered Anglican-believing officials in the northern Albemarle region. By 1711, political tensions had led to another brief rebellion—a semi-violent bid for political control that came to be known as Cary's Rebellion—pitching professing Anglicans (who hadn't bothered to build a church) against zealous Quakers. As you may have guessed, the more violent religion won.

As a result of the Anglican victory (assisted by the military presence of troops from the Virginia Colony), Quaker influence was forever diminished in the Carolinas—and keeping the peace would become much more difficult. With Anglicans eager to expand the colony (that is, to remove Native Americans from their lands) and Lord Proprietors committed to growing their income, the colonies' new leadership began to pursue a more expansionist approach. Had they known the price, they may have defaulted to Quaker sensibilities.

Early on, Quakers and Anglicans found little in common.

Quaker Oats, established in Ohio in 1901, was named after the Quaker religion. In 2001, Quaker Oats was purchased by the Pepsi-Cola Company, which was founded in NC. Quaker Oats, no thanks to Anglican palates, had come home.

1711: TUSCARORA WAR

By the early 1700s, historians estimate that Carolinians had enslaved around thirty-five thousand Native Americans, sending them to the northern colonies or shipping them abroad. Adding to the insult, Indian tribal groups had been pushed out of familiar hunting grounds, supplies of game were becoming scarce along the coastal regions and epidemics of smallpox had decimated native populations. Native American resentment and retaliation were on the rise—and a fully operational Euro-Indie Disorder was in the works.

Among the coastal Indians of Carolina, the Tuscarora proved to be the most resistant to colonial influence. As the Tuscarora observed the struggles of neighboring tribes, they began to develop alliances with their former Algonquian enemies—the Coree, Matchapunga, Pamlico, Bear River and Neusioc. Meanwhile, a number of Siouan tribes—the Yamasee, Catawba, Waxhaw and Waccamaw—eager to maintain trade for weapons and goods, allied themselves with the settlers. Tensions were building, and the Tuscarora, in a bold move to stop the advance of the colonists, planned a well-coordinated attack.

Regrettably, John Lawson stumbled upon a Tuscarora tribe prior to the assault and became the poster child for Tuscarora revenge. On September 22, 1711—two days after Lawson's murder—the Tuscarora unleashed their full vengeance on the unsuspecting colonists, killing over 140 men, women and children. Destroying crops, livestock and homes, the Tuscarora hoped the colonists would settle for a quick peace. Instead, the settlers counterattacked with brutal effectiveness. For months after, coastal Carolina was in a frenzied state of confusion and bloodshed. While the Indians continued to pick off one settlement after another, the colonists sought help from their neighboring colonies and Indian allies (the Quakers continued to distance themselves from leadership by refusing to fight).

When the dust and blood settled, the Tuscarora War claimed the lives of hundreds, sanctioned brutality between Native Americans and Europeans and left the Carolina Colony in ruins. After two years of savage war, the Tuscarora were completely decimated and would never again roam free in the Carolinas. Many of the Tuscarora relocated to the north and joined the Iroquois, but a small band agreed to peace and was assigned to a tiny reservation in the southeast.

Ultimately, the Tuscarora defeat opened up the Piedmont to easy settlement, and soon another wave of settlers would be pushing west—this time, knocking on the door of the Cherokee.

1717: Pirates

While Native American lands were being confiscated, North Carolina merchants were experiencing a bit of payback. During the early 1700s, in a twist of scalawag irony, the coast of North Carolina had become a convenient haven for colonial pirates. Taking advantage of the treacherous waters and hidden coves of the Carolina coastline, a long list of pirates had begun confiscating private property—in the form of merchant ships and their valuable cargo.

Carrying marketable goods between the colonies and to and from England, the Atlantic Ocean was bustling with ships waiting to be plundered. Absconding with prized goods that could be resold in the colonies, pirating had become a very profitable endeavor. This indirectly benefited colonial settlers while bringing a small number of merchants to financial ruin.

The local pirate economy may have operated in this way: a vessel from Massachusetts would head down to the Carolina coast bringing goods to be sold to the colonists and hoping to return with a boat load of tobacco to be resold in New England; pirates would intercept the vessel on the front leg of the trip and relieve it of its cargo (leaving the merchant with no cash and sometimes no ship); and the goods were then resold by the pirates to the aforementioned colonists at half the price, undermining local businesses.

As long as the colonials didn't care where the goods came from (most didn't), they took home the same product at a substantial discount, the pirates made a decent fortune and most everybody went home happy (clearly, a Walmart economy). To make matters worse, corrupt government officials often aided the process by protecting the pirates from legal or military recourse.

By 1717, this lawless behavior had become common along the North Carolina coastline, and with growing merchant frustrations, a royal edict was eventually proclaimed; in exchange for abandoning their lucrative efforts, King George I offered a full pardon to all pirating parties. It was a bold, daring and silly move. Hoping to break up the pirate mob, King George ultimately provided a brief pirating sabbatical that would prove all too short for seafaring merchants.

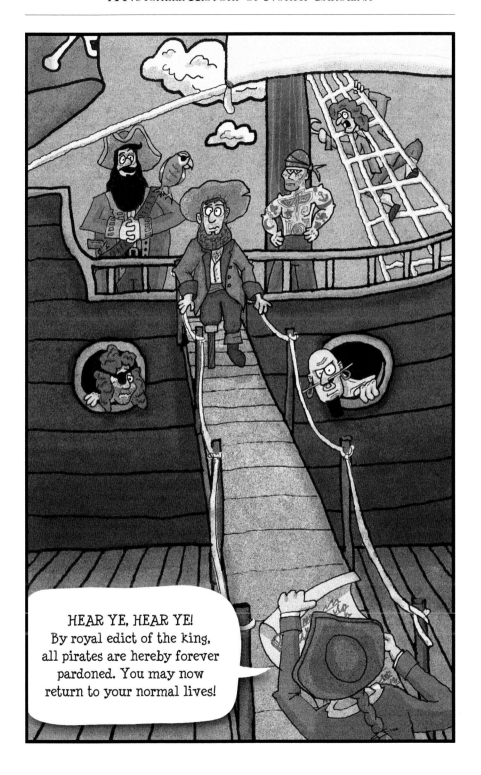

1718: BLACKBEARD

Many of the colonial pirates had begun their illustrious careers as privateers—owners or operators of privately owned ships authorized by their governments to attack and plunder enemy ships. **Mercenaries** of the high seas, privateers were often funded by investors looking to gain a profit from stolen goods. Governments that sanctioned privateering relied on their stealth and unethical behavior to strike fear in the enemy.

Edward Teach was one such privateer. Originally authorized by the British government during Queen Anne's War (fought against the French), Teach opted to continue his privateering after the war ended—downgrading his status to pirate and freeing himself to attack friend or foe. In 1717, after several years' service on a pirate ship (learning the ropes), Teach captured a large French ship, renamed it *Queen Anne's Revenge*, dressed for the occasion (adopting a hellishly scary look) and was given the name Blackbeard by his victims—referring to his waist-long beard, braided in pig tails and decorated with ribbons.

For months, Blackbeard wreaked havoc along the Virginia and Carolina coasts. By the time the royal pardon was offered, Blackbeard had ransacked more than twenty vessels and commanded a crew of over 250 men. Blackbeard eventually surrendered to Governor Eden of North Carolina, who honored the king's pardon. With a show of normalcy, Edward Teach then proceeded to purchase a home in the town of Bath (just down the street from the governor's house) and married a local plantation owner's daughter. His good citizenship lasted all of three months.

Returning to his old pirate haunt on Ocracoke Island, Teach resumed his trade with unfortunate zeal. Upon learning this news, Governor Spotswood of Virginia had had enough—enough of the lackadaisical Carolina government that refused to curtail Blackbeard's activities and enough of the damages to Virginia's economy. Spotswood ordered a crew of British naval officers to bring a halt to Blackbeard's terror on the high seas. On November 22, 1718, British sailors trapped Blackbeard and his crew in Ocracoke Inlet and, after a harrowing fight, ended his career on a permanent basis. Blackbeard's body was thrown into the drink, but not before his head was severed and placed on the bowsprit of the victorious ship—which made its way back to Virginia with a small entourage of captive pirates and their booty.

1729: ROYAL COLONY

Despite the removal of the Tuscarora and the pirates, the Carolinas predictably remained somewhat of an unruly place. Taxes were not easily collected, colonists bickered among themselves, land disputes were common and law and order was not easily upheld. The king of England and his Parliament were convinced that the Lord Proprietors were not managing their colonies particularly well.

In 1719, the South Carolina Colony was begrudgingly sold back to King George I—with a proverbial slap of the hand—and promptly designated a Royal Colony. Under his royal rule, the king appointed the colony's governor and its officials and held the right to make laws and approve or overturn colonial-approved laws—a strategy identical to the one the Lord Proprietors had utilized to administer the colonies (administrative hint: this strategy didn't work the first time).

In 1729, feeling somewhat weary of the whole affair, seven of the eight Lord Proprietors also agreed to sell their shares of North Carolina back to the king, effectively bringing all of the Carolinas under royal rule—with one small exception. One of the Proprietors, Lord Carteret, refused to sell his property, which contained one-eighth of the colony's land. This tract of land would be known as the Granville District and would eventually be appropriated—for nothing—by the victors of the American Revolution. For now, most of North Carolina had become a Royal Colony.

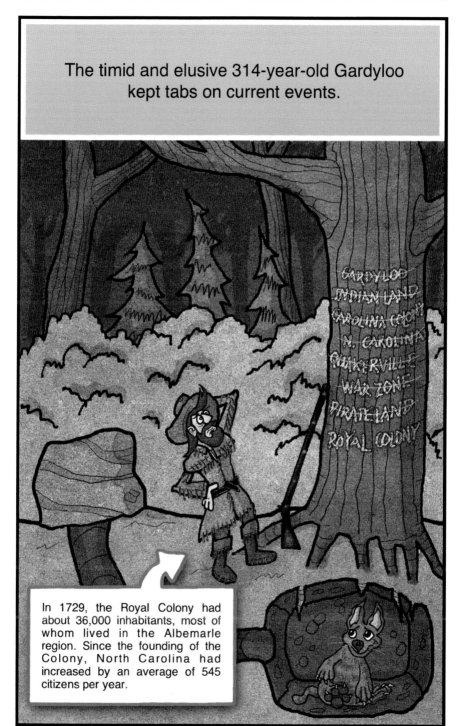

1745: Settling the Piedmont

Due to the ongoing problems in Europe—religious persecution, wars, famine, the usual lack of land and the inability of most citizens to rise above the rank of common peasant—it is estimated that by the mid-eighteenth century, over 400,000 people had made the grueling trek to America. Among those hearty travelers were the Welsh (singularly famous for birthing the namesake of Mount Everest), the Scottish-Highlanders (of Braveheart William Wallace fame), the Moravians (German Protestants), the Scots-Irish (an ethnic group from Ulster, Ireland, consisting mostly of Presbyterians) and, of course, quite a few other white folks from England (known for colonizing much of the entire planet).

By 1745, most of the southern coastal regions of North Carolina had been settled by the Welsh and Scottish-Highlanders—made possible by the discovery of the Cape Fear River and its easy access from the coast. Meanwhile, the Moravian and Scots-Irish immigrants had moved into the colony of Pennsylvania, hoping to carve out a community that would support their religious beliefs. But by 1745, many of these settlers had begun to feel crowded and concerned, troubled about maintaining their religious lifestyle in the growing Pennsylvania colony and apprehensive about recent Indian attacks along the Pennsylvania frontier (see "French and Indian War"). In response to these factors, many of these second- or third-generation immigrants began traveling the **Great Wagon Road** into the Piedmont region of North Carolina.

Utilizing this crude wagon trail, the Moravians settled an area they called **Wachovia** (an area that currently includes the cities of Bethania and Winston-Salem), and the Scots-Irish invaded the rest of the Piedmont, quickly filling its hills and valleys, spreading south and west up to the foothills of the Appalachian Mountains. In a seven-year span, the legislature of North Carolina created five new counties to oblige the onslaught. Benjamin Franklin estimated that over forty thousand residents of Pennsylvania relocated to North Carolina during this period.

One of these families, of English descent, would be the proud parents of the most famous frontiersman in American history.

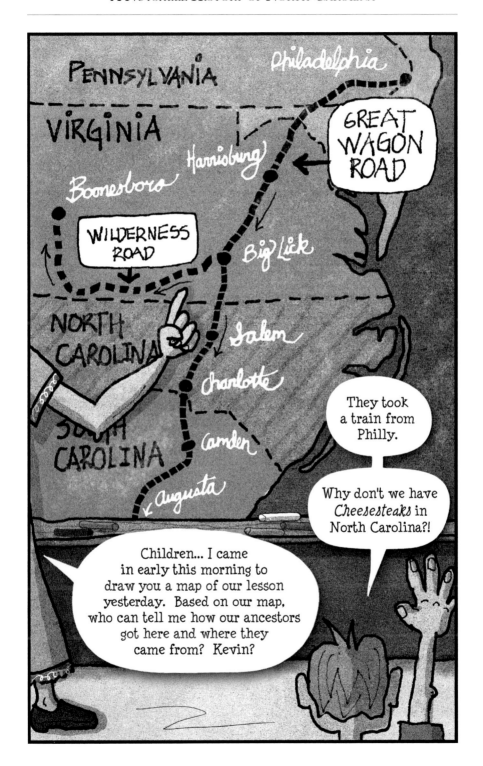

1750: Daniel Boone

In 1750, the Squire Boone family followed the great migration of Quakers from Pennsylvania, settling in Mocksville, North Carolina, on the edge of the Carolina frontier (twenty-three miles east of present-day Statesville). Daniel, their sixteen-year-old son, would shun his Quaker education, choosing instead to roam the Blue Ridge and Appalachian Mountains—yielding a passion for wilderness adventure that would endure his lifetime.

During his twenty-one years in North Carolina, the five-foot-eight Daniel Boone fought in the French and Indian War, married Rebecca Bryan, fathered nine children, fought in Lord Dunmore's War and skirmished against the Cherokee and Shawnee during the American Revolution. When Boone wasn't fighting or raising children, he provided for his family as a **Longhunter**, engaging in extended hunting trips into what would become Tennessee and Kentucky.

At the age of forty-one, Boone departed North Carolina to blaze a trail into the westernmost portion of colonial civilization, eventually building a new settlement in Kentucky (Boonesboro) and paving the way for thousands of settlers in the push westward. Called the Wilderness Road, the project was commissioned by a group of North Carolina land speculators (the Transylvania Company), who hired Boone to build a trail that would ease the arduous two-hundred-mile journey for would-be settlers (the company's claim on the land would eventually prove to be illegal). Boone would build the trail—fighting the Shawnee, who claimed the land, along the way—father another child, be elected to three terms in the Virginia legislature, eventually lose all his landholdings in Kentucky and spend his final twenty-one years hunting and exploring in the Spanish-held Louisiana Territory (in what would become Missouri).

His life, purportedly crowded with hair-raising close calls, daring escapes and stupendous rescues (he once traveled three days to track down and rescue his daughter, who had been captured by the Shawnee), would shame a modern-day Rambo. Boone's famed adventures were chronicled in scores of books—many written, as Boone suggested, "only in the regions of fancy"[1]—shaping him into the quintessential frontier hero of the colonial period. To date, his name is attached to more than five hundred establishments honoring his exploits in Pennsylvania, North Carolina, Virginia, Tennessee, Kentucky and Missouri. He has been claimed by National Forests, schools, cities, commemorative trails, historic markers, museums, restaurants and campgrounds, including one of his old campsites, Boone, North Carolina.

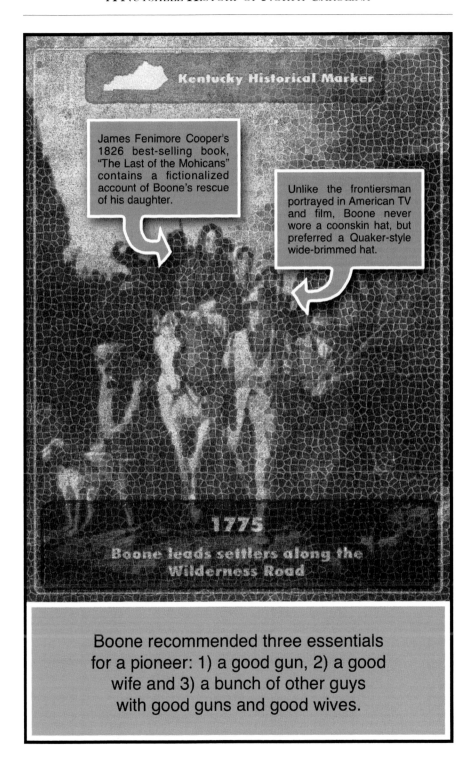

Boone recommended three essentials for a pioneer: 1) a good gun, 2) a good wife and 3) a bunch of other guys with good guns and good wives.

1751: FIRST NEWSPAPER

Uniquely uninterested in media consumption, early North Carolinians relied exclusively on other colonies for any appraisal of semi-current events. Boston had published its first newspaper by 1690, South Carolina in 1732 and Virginia followed suit in 1736. It would be another fifteen years before North Carolina would consider such an amusement.

For the most part, North Carolinians were untroubled by the inconvenience of waiting weeks or months to receive the latest ramblings from England or colonial America. With land to clear, houses to build, farms to develop, children to raise, products to manufacture and, if you were Daniel Boone, Indians to fight, reading new news, old news or any news seemed trivial. Newspapers that did inadvertently trickle into the colony originated in Virginia and were most likely consumed by literate citizens—which, early on, composed a small portion of the population.

Eventually, ninety-two years after Nathaniel Batts established the first permanent home in the colony, North Carolina received its first printing press. Concerned about the need for printing its own currency and updating its long list of undecipherable laws, the North Carolina legislature decided to acquire a printer and his associated tools. James Davis, an accomplished printer from Virginia, was promptly hired and directed to set up shop in the town of New Bern. Serving as the official printer of the colony for thirty-three years, Davis quickly put his skills to work, producing the *North Carolina Gazette* in August 1751, the colony's first newspaper. Offering the "freshest advices, foreign and domestic,"[2] a typical issue included colonial directives, lively essays, brief editorials, a smattering of local news and announcements and, of course, irritating advertisements. If a reader were lucky, the news might be only two or three weeks old.

1754: The French and Indian War

Although it wasn't recorded in the unpunctual newspapers each month, most American colonials living on the western frontier recognized their tenuous position. That is to say, they were keenly aware that other parties were vying for their land (that is to say, the land they took from Native Americans).

By the mid-eighteenth century, the current threat lay mostly with the French and their Indian allies, who had joined together to secure the Ohio Valley. The threat intensified when the French fortified several strategic points along the Ohio River—which at the time was also claimed by Virginia. Seeking their removal in 1754, Virginians led by the twenty-one-year-old George Washington proved to be unsuccessful, and the French and Indian War was officially on.

Initially, the Cherokee aligned themselves with the British and fought in the Ohio Valley and Pennsylvania. But in 1758, a misunderstanding with the British led to stolen horses and a retaliatory attack by VA farmers. The Cherokee tide of opinion quickly changed, and a war within a war (perceptively called the Anglo-Cherokee War) erupted in the backcountry of VA and NC. The Cherokee attacked many small farms on the Carolina frontier, killing white settlers and burning their homesteads, ensuring a vengeful response from the colonists. After both factions had shed comparatively equivalent portions of blood, the NC militia defeated the Cherokee, and a treaty was signed in 1761.

On the French front, after several deflating losses, the British colonies began to organize themselves and eventually developed a strategic plan of attack, defeating the French at Quebec in 1759. With fighting between France and England continuing on other continents—and Spain joining the war effort against the British—the official French and Indian War (now dubbed the Seven Years' War by Europeans) continued until the Treaty of Paris in 1763. The resulting land grab left the British with all French territories east of the Mississippi and all of Spanish-held Florida (the future home of Disney World was secured).

Unfortunately for the British, the French and Indian War had taught colonial America that strength, independence and victory lay in cooperative numbers. The war also left Britain in a huge financial hole, and its attempts to impose taxes on the colonials would eventually translate into a coordinated and feisty discontent—particularly in Massachusetts and North Carolina.

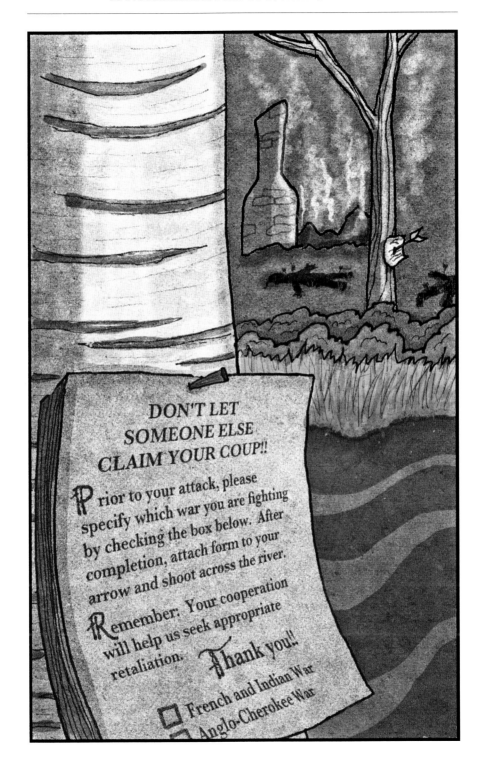

1760: THE EAST-WEST CONUNDRUM

At this point in our story, North Carolina had experienced two separate colonizing movements, an eastern and a western. Eastern settlers had migrated down from Virginia or unpacked their European bags along the Cape Fear River. These easterners eventually established productive farming and trading communities afforded by fertile plains and coastal waters. Their efforts were subsidized by a growing population of slaves. Eastern colonials grew in wealth, political power and educational opportunities—and maintained close ties with Britain.

Western settlers, as we have learned, came primarily from Pennsylvania and populated the hilly, less fertile valleys of the Piedmont. They tended to be a more independent, self-sufficient lot, relying on their own labor and resourcefulness to meet their daily needs—finding success in hunting, small farms and manufacturing (producing goods they were unable to purchase). To market their products, western settlers traveled trails and river routes, which headed southeast into South Carolina; consequently, there was very little interaction between eastern and western North Carolinians.

The unique differences between these two populations—separated by geographic distance, genealogical background and British loyalties—led to a high level of distrust and congenial animosity. With the royal colonial government residing in the east, westerners found little representation of their needs in the growing frontier. Easterners maintained a monopoly on legislative decisions, and the officials appointed to govern the western regions (conveniently chosen by eastern officials) were often corrupt—collecting illegal fees and exorbitant taxes to line their own pockets.

At the close of the French and Indian War, westerners felt isolated and neglected. Demanding equal representation in government affairs, honest government agents *and* equal dispersal of tax funds (for the construction of roads and schools), western voices fell on deaf ears. Tempers would soon flare, and the American colonies would experience the first violent revolt against their own government. The Regulator Movement, as it came to be called, produced the early rumblings of a people yearning for a fair system of self-government (preferably, one without taxes).

1766: The Regulator Movement

With a tax structure that continued to favor wealthy easterners, a few irate citizens of the Piedmont began to organize themselves in protest. Complaints to the eastern-dominated, British-backed legislature focused on illegal taxes and indifference to the plight of the poor backcountry farmers.

In 1766, a polarizing decision by the legislature escalated the conflict to a new level of frustration. Voting to permanently establish New Bern (on the east coast) as the capital of NC, and appropriating tax dollars to build a palatial mansion for their new governor—British officer William Tryon—the plantation owners and merchants from the east doused any hope of kindling warmth with the westerners. A wave of dissent swept the backcountry, and the newly enraged westerners formed themselves into a band of Regulators—a term that embodied their new plan of attack: "to regulate abuses of power."

Hundreds joined, refusing to pay taxes until they were satisfied that colonial officials were obeying the law. In 1768, violence erupted. When a western sheriff chose to confiscate a farmer's horse to cover his unpaid taxes, all hell broke loose. A force of seventy Regulators reclaimed the horse and put the sheriff on notice: "Don't mess with us." In response, Edward Fanning (considered the chief of corrupt officials), placed the Regulator leaders under arrest. Regulators responded with a force of seven hundred men, surrounding the jail and demanding their release. Fearing for their lives, the guards implemented the demand without delay.

Over the next two years, tensions escalated. When a small group of noncompliant Regulators were scheduled for trial, a large force of fellow Regulators attacked the courthouse, pummeled Fanning to within an inch of his life and destroyed several public buildings. A full-scale rebellion was on.

Governor Tryon mustered a militia of one thousand men and marched to meet the Regulators on their own turf. In May 1771, Tryon's forces met an undisciplined army of over two thousand men at Alamance Creek. After a two-hour skirmish, casualties were light, the Regulators dispersed and the movement's leaders were rounded up and hanged (justice was served, British style).

At the end of the day, the Regulators had lost the first battle in the struggle for equal and fair representation. But their point had been made: "If you push us far enough, we will fight." Within five years, this sentiment would echo across all of the thirteen American colonies.

1768: The Graveyard of the Atlantic

Having slowed the invasion of Europeans, dictated population growth and trade routes, encouraged pillaging and indirectly started a war, the Carolina coastline was, by 1768, quite famous.

In the ten-year period between the Regulator Movement and the onset of the American Revolution, the waters off the North Carolina coastline were also dangerously effective at sinking ships, damaging egos and generally wreaking havoc with the maritime industry. The fact of the matter is: the Carolina coast had always been this way. According to maritime records, hundreds of ships had been lost by 1768.

First and foremost of peril was the hazardous two-hundred-mile stretch of thinly vegetated islands lying just off shore. These barrier islands, referred to as the Outer Banks, inhibited access to the mainland and offered deceptively navigable intercoastal waters—waterways between the islands and the shore that were often swarming with hidden sandbars.

Next on the list of hazards, regular and violent hurricanes pounded this region of the Atlantic, typically in the months between August and October. The first reported shipwreck occurred in 1526 and was likely due to this extreme weather. As you'll recall, even the "Lost Colony" rescue operation was abruptly terminated by these howling gales. Encountering one-hundred-mile-an-hour winds, ship's captains were left with two options: 1) drop sail, sink a few anchors and hope to ride it out or 2) minimize sails and let the wind blow you somewhere else. Apparently, neither option was particularly successful.

Finally, and most fatal, certain vocations along the Carolina coast—specifically, privateer and pirate—sent many a ship into the dark depths.

By the twentieth century, North Carolina's coastline would be deemed the Graveyard of the Atlantic, adding to its obituary the Civil War ironclad USS *Monitor* and becoming a favorite shooting range for German U-boats—which incidentally sunk almost four hundred ships along the Outer Banks during World War II (see "The Outer Banks War").

1770: THE NAVAL STORE INDUSTRY

A British officer visiting North Carolina in the 1700s noted "a universal gloomy shade, rendered dismal by the intermixing branches of the lofty trees, which overspread the whole country, and [which] the sun never pervades." Counter to his morose perspective, the officer was observing one of the spectacular riches of deciduous North Carolina, an immense, seemingly endless sea of trees—pine, oak, cypress, sycamore, poplar, chestnut, hickory, walnut, maple, cedar—spread in an unbroken wave of shaggy green across the entire colony, from coast to mountain. To the military eye, fresh from the bonny shores of tree-deficient Britain, this was perhaps a foreboding and gloomy sight. To the carpenter, furniture maker, **cooper** and shipbuilder, this was indeed a glorious spectacle to behold—and to exploit. For wood-depleted, ship-hungry Europe, Carolina would become a godsend.

Although other colonies contained their own abundant supply of timber, cultivated plants and other industries had proved to be more profitable. The southern colonies, in contrast, contained one unique species that would prove to be vital to the Carolina economy—and to the British shipping industry. *Pinus pilustras*, commonly called longleaf pine, covered almost ninety million acres of the southeastern colonies, and North Carolina was flat-out smothered in it, from coastal plain to Piedmont. By 1770, due to the longleaf pine's singularly sticky sap and long, straight trunk, North Carolina had become the largest producer of naval stores in North America.

A term not so common today, naval stores referred to products used in the manufacture of ships. Including but not limited to such tree-bearing products as wood, tar, pitch and turpentine, longleaf pine could crank out all four in prodigious quantities. Most importantly, longleaf pine produced the dark resins (tar and pitch) that were essential to waterproofing the hulls and masts of oceangoing vessels. These longleaf qualities produced a unique industry that prospered along the Carolina coast and eventually played a role in the American Revolution ("Hey, Britain, want some naval stores? Too bad!").

Unfortunately for future North Carolinians, within 150 years, the naval store industry had completely decimated the pine forests. Once described as "an endless sea of pine-scented timber," today less than 3 percent of the original longleaf pine forest remains.

The Longleaf Pine is the official state tree of NC, although Loblolly Pine has replaced it as a commercial species.

1771: CAROLINA SLAVERY

For any enterprising man in the eighteenth century, labor was the key to riches in the state of North Carolina. With an abundance of cheap land, all one needed was a small investment of capital and cheap labor to make that land pay off. For a rural farmer with a crop to grow and sell, cheap labor often came in the form of children. For a man owning a vast forest of longleaf pine (and a malleable conscience), slaves were the answer.

The original Lord Proprietors had encouraged slavery from the start of their grand experiment. It took no high-tech investment software to recognize that slavery would ensure economic activity—and increase potential income for the exalted Lords. The Virginia colony had proven that slavery paid big dividends, as witnessed by the large plantations and beautiful homes of the local aristocracy. North Carolina, with its access to slave traders and fertile valleys, would become the next colonial incubator for southern slavery—and for good measure, the Lord Proprietors had written it into law. There was only one problem with their dubious plan: the North Carolina coastline.

As we learned earlier, the Carolina seaboard had proved to be a daunting port of entrance. With only the southern ports of Cape Fear and Wilmington accessible to slave-trading ships, plantation development was slow to advance. Due to its poor coastline, most of North Carolina would never attain the large-scale, slave-affluent economies boasted by Virginia and South Carolina, and this would play a ginormous role in the future personality of the state.

Despite this welcome setback, slavery did manage to gain a firm foothold in the young province. While the southeastern coast gained some measure of slave-powered prosperity, a less-intensive slave economy developed in other portions of the colony. Trickling in from Virginia or South Carolina, slaves were acquired for labor on small farms or to assist in the development of family-owned businesses. So popular were the economics of slaveholding—and emblematic of one's social status—even the Cherokee took to owning slaves. Although non-slaveholders were always more numerous in North Carolina, the slaveholding few were typically wealthier, more politically connected and more powerful. The industry of slavery, its affluence and cruelties, would cast its shadow over the state for the next one hundred years.

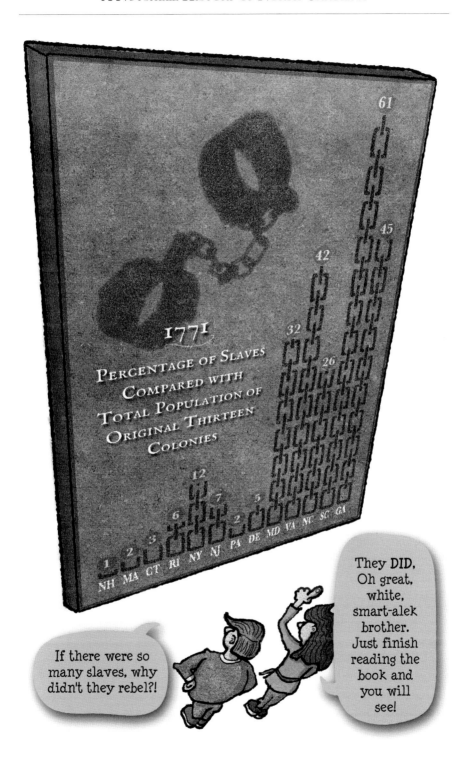

1772: The Rice Plantation

As early as the 1690s, rice plantations had become lucrative along the South Carolina coast. Two factors led to its success: 1) the southern Carolinas offered the swampy and temperate conditions ideal for rice production, and 2) West African slaves, who had been growing rice for centuries, provided the skill and know-how to ensure profitabillity. With easy access to slave markets, by the 1720s, rice had become South Carolina's most profitable export.

In search of more profit, South Carolina planters (and their slaves) slowly filtered north, bringing their expertise to the North Carolina colony. Despite the huge investment required to convert swampland to rice production, slavery tipped the economic scales, making the labor-intensive product cost-effective. By 1772, rice had become second only to naval stores in North Carolina export value.

Rice output, for the hapless slave, was a miserable career. Working knee-deep in snake- and bug-infested swamps, fields had to be cleared, canals dug, dams built (to flood and drain the rice fields) and rice planted and harvested, then threshed, polished and sold. It was a grueling life, and field managers and slaves alike suffered disease and injury.

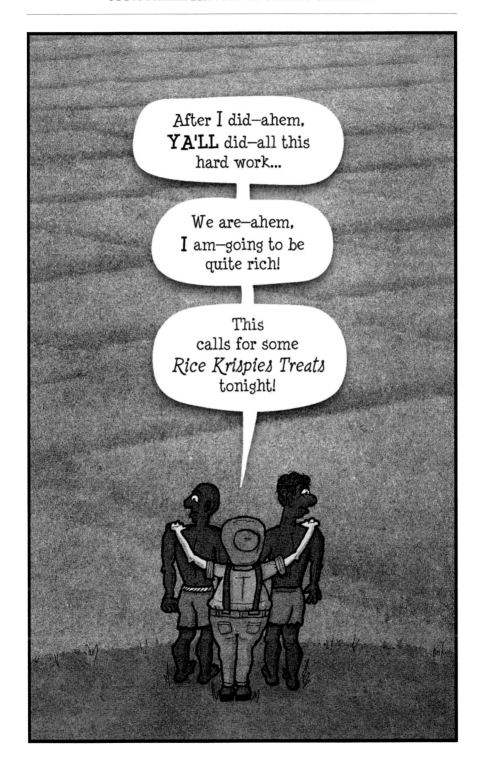

1774: Edenton Tea Party

Although the collapse of slavery and rice plantations were considerably in the future, a royal collapse was brewing on the near horizon. As you may recall, the British influence was periodically unwelcome in North Carolina (see "Culpepper's Rebellion and Regulator War"), and as time progressed, as it always does, this sentiment continued to swell.

In the early years of the royal colonies, Britain was content to regulate trade through a series of Navigation Acts while allowing the colonies to mostly govern themselves through their own colonial assemblies. All this changed after the French and Indian War. Intent on bringing their colonial neighbors under firmer control—and convinced that the colonies should help pay for the British military presence in America—Parliament enacted a series of laws to expedite this strategy. Assuming that Parliament had every right to tax its royal colonies, these statutes included such wildly popular laws as the Townsend Acts, the Tea Act and the Stamp Act—laws that established small fees (taxes) for the purchase of tea, newspapers, playing cards and other commonly used merchandise.

The colonials were not fond of these developments and responded accordingly by boycotting products, relying on smuggled goods or dumping tea in the Boston Harbor. In 1774, the women of North Carolina took an unusual and historical stance on the issue.

Inspired by the events of the Boston Tea Party, Penelope Barker (at the time, the wealthiest woman in all of North Carolina) wrote a letter to the women of Edenton suggesting that they boycott a number of British products, including tea. Gathering in her home, fifty-one women signed a statement describing their patriotic intentions. Endearingly called the Edenton Tea Party, Penelope mailed a copy to a London newspaper, including the following statement: "I send it to you, to shew your fair countrywomen, how zealously and faithfully American ladies follow the laudable example of their husbands, and what opposition your Ministers may expect to receive from a people thus firmly united against them."[3]

In classic British fashion, the newspaper printed the statement with a complementary editorial cartoon, poking fun at the women of North Carolina. Despite the rib, Ms. Penelope and her entourage became some of the first women in American history to pursue political involvement, and her efforts inspired others to take a stand against the British government.

1775: SEEKING INDEPENDENCE

As hostilities grew between the colonials and the British, most Americans continued to view themselves as loyal British subjects. Much of their anger grew from the abuse of their natural English rights—according to English law, they had a right to representative government and could be taxed only by that representative government. Feeling that the British Parliament had consistently overstepped its bounds, the colonial leaders (whose efforts were concentrated in New England and Pennsylvania), continued to push for change. That push came in the form of public protests, patriotic rallies, secret meetings, civil disobedience and the extravagant dissemination of propaganda to support their cause.

As the British responded with stricter regulations and a stronger military presence, colonial leaders finally appealed to the king himself. When King George III rejected their appeals, condemned their rebellion and sent troops to quell their complaining, he inadvertently closed the door on his provincial investment—and propelled his mutinous colonial empire toward independence.

With negotiations deadlocked, American independence became the new and improved colonial imperative. As the fervor for independence mounted, so did the call for a new American government. On April 19, 1775, ignited by the shots fired at Lexington and Concord, the American Revolution exploded across the eastern seaboard.

For the North Carolina colony, the Revolution offered the hope of independence and the certainty of conflict. Unsurprisingly, about half the colony supported the revolution (the Whigs), about 25 percent remained loyal to the Crown (the Tories, who resided mostly on the east coast) and the remaining 25 percent only wished to be left alone (we'll call them the Loners). Many slaves took the opportunity to side with the British (hoping for freedom), a few escaped (seeking asylum in the north) and some fought for the Revolution (incorrectly assuming that colonial victory would translate into freedom). The Cherokee sided with the British, and British Americans (that is, those serving in official capacity), well, they fought for the motherland.

As a true Declaration of Independence began to formulate in the minds of the colonists, North Carolinians were assured of one thing: this Revolutionary War was likely to resemble a civil war.

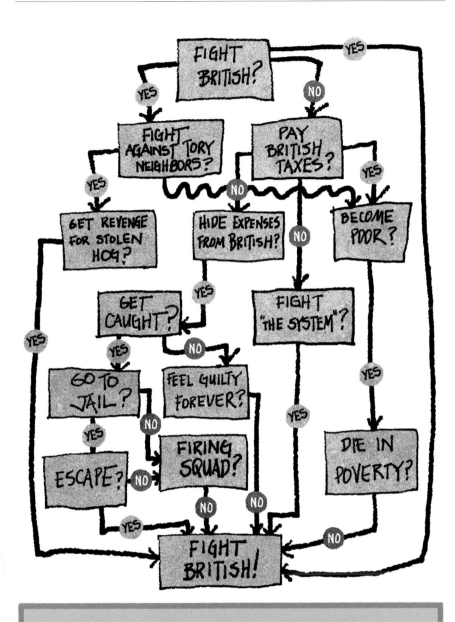

Facing a tough decision, Pete drew
a simple flow chart. Eventually,
his decision became clear.

1775: THE MECKLENBURG RESOLVES VERSUS THE MECKLENBURG DECLARATION

In the month following the battles at Lexington and Concord, a most controversial meeting took place in Charlotte, NC. Facing an uncertain future, the Mecklenburg County **Committee of Safety** felt an urgent need to express its feelings toward the British empire. Acutely aware that statements like, "This country ain't big enough for the two us" would be lacking in political clout, the committee formulated a series of resolutions.

Cleverly termed the Mecklenburg Resolves, the Charlotte-based committee produced a series of statements intended to diminish British authority. Proclaiming the dissolution of British rule "until further notice," the Resolves established a few ground rules for county government, military conscription, the collection of taxes and the settling of disputes—until the Provincial Congress of North Carolina had made other arrangements.

Curiously (this is where the controversy comes in), the Mecklenburg Resolves eventually disappeared from the historical record. This document was apparently lost in an early 1800s fire, and no copies survived. As told by historians, these original Resolves were adopted on May 31, 1775.

According to "suspect" historians (those particularly passionate about the state of North Carolina), preceding the writing of the Resolves, the Mecklenburg Committee of Safety had, for some unknown reason, assembled on May 20 (eleven days earlier) and approved a contradictory document: a Declaration of Independence from Britain. This document, unknown to anyone prior to its discovery in 1819, was purportedly recovered by the son of the clerk who had attended the May 20 meeting. Copied from a "copy" of the original (which had suspiciously disappeared), the document suggested that NC had actually declared independence from Britain more than a year before Thomas Jefferson's Declaration of Independence.

This was *big* news. Despite the questionable integrity of the document (and wording strangely similar to Jefferson's), news of the Mecklenburg Declaration, as it came to be called, spread like wildfire across the state. Unfazed by the realities of a hoax, the North Carolina legislature fervently endorsed the story and officially memorialized the date of the Mecklenburg Declaration on the state flag in 1861. May 20, 1775, remains patriotically embroidered on the state flag to this day, proclaiming North Carolina as the "First in Independence."

1775: First Bonfire

Until July 18, 1775, the Patriots of North Carolina had remained nonviolent. Content to boycott British laws and stoke patriotic fires, Whig leaders had been slowly gathering support for the move toward independence. Characteristically well organized, colonial militias had been raised; supplies were gathered and strategies deliberated. But on this date, in somewhat uncharacteristic fashion, about five hundred Patriot **Minutemen** burned down all the buildings inside Fort Johnston, a British-held fort along the Cape Fear River. The developments leading up to this bonfire, and the ensuing battle, are certainly worth telling.

It happened like this. Royal Governor Martin (who had replaced Tryon) was a thoroughly red-coated citizen of North Carolina. He despised the Patriot movement and did everything within his power to make its efforts ineffectual. Angered by the Patriots' provincial meetings (to which he was not invited) and outraged that these meetings included most of his colonial delegates, he eventually dissolved the entire North Carolina Assembly.

Recognizing his dire condition ("me against the world"), he called for military backup. Believing that a large contingent of Loyalists would rally to his cause, Martin began raising an army of Scotch Highlanders who remained loyal to the Crown. Simultaneously, he requisitioned an army of 4,600 British soldiers, coming by sea, to rendezvous with his army at Wilmington. Together, they would push north through the colony and crush the rebellion. Unfortunately for Martin, his plan was discovered, and Patriot forces began responding in strangely violent ways (like throwing stuff at his house).

Fearing for his life, Martin left his palace at New Bern and moved into Fort Johnston, along the Cape Fear River. Learning that Patriots were headed his way, Martin promptly abandoned the fort and relocated to a British sloop moored off shore. After Martin relinquished his post, the Patriots burned the fort (an exceptional bonfire) and took control of the region.

Undaunted by his new headquarters, Martin continued scheming—convinced that these minor setbacks would soon be forgotten when an overwhelming force of British regulars and Loyalists arrived to restore him to power. Expecting the British at any moment, Martin commanded his Highlander army to move toward Wilmington. Patriots rallied to cut the them off and prevent their rendezvous with the British. The ensuing battle would be North Carolina's largest, and only, victory of the Revolutionary War.

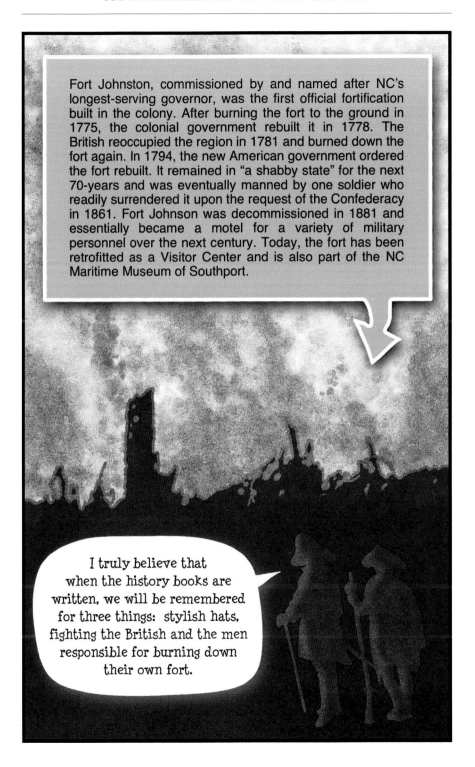

Fort Johnston, commissioned by and named after NC's longest-serving governor, was the first official fortification built in the colony. After burning the fort to the ground in 1775, the colonial government rebuilt it in 1778. The British reoccupied the region in 1781 and burned down the fort again. In 1794, the new American government ordered the fort rebuilt. It remained in "a shabby state" for the next 70-years and was eventually manned by one soldier who readily surrendered it upon the request of the Confederacy in 1861. Fort Johnson was decommissioned in 1881 and essentially became a motel for a variety of military personnel over the next century. Today, the fort has been retrofitted as a Visitor Center and is also part of the NC Maritime Museum of Southport.

I truly believe that when the history books are written, we will be remembered for three things: stylish hats, fighting the British and the men responsible for burning down their own fort.

1776: FIRST BATTLE

Commissioned by Governor Martin and led by General MacDonald (sounds Scottish), on February 18, 1,600 Highlanders began the ninety-five-mile trek to Wilmington. Eager to unite with the British, they were quick-stepping their way toward what they hoped would be a Loyalist revival. Although the Scots were not eager to shed their blood for King George, the thought of being ruled by a common lot of rebellious neighbors had no appeal to them. So off they went.

Shadowing their every move, colonial informers directed the maneuvers of the Patriot force of 1,100 men, led by Colonel Moore (of the First North Carolina Continentals), Colonel Caswell (leading the militia of the New Bern District) and Colonel Lillington (with the Wilmington District militia).

Hoping to intercept the Highlanders before they reached the sea, Caswell and Lillington set a trap on the east side of Moore's Creek Bridge (a necessary river crossing eighteen miles northwest of Wilmington). Arriving at dawn and finding what appeared to be a small number of Patriot forces, MacDonald ordered an attack. Charging across the plankless and well-greased bridge rails, the Highlanders received a well-placed barrage of cannon fire and musket balls, launched by colonials hidden in the adjacent woods. The battle was over in minutes, with the Highlanders suffering over 50 killed and the Patriots losing just one man. In the panic of the retreat, Moore's men (who arrived late to the battle) and the advancing Patriots from Caswell's and Lillington's forces, rounded up over 850 prisoners in the days following the Battle of Moore's Creek Bridge.

While Governor Martin had hoped to gain an early victory and rally Loyalist support, instead the lopsided thrashing at Moore's Creek bolstered the Patriot cause and encouraged the Provincial Congress of North Carolina to crank up the pressure for independence.

When the British finally arrived in Wilmington, the only one to greet them was a sheepish Governor Martin. They picked him up and left. The first battle for the heart of North Carolina had pitched neighbor against neighbor, and the crushing Loyalist defeat destroyed any hope of a successful British invasion. It would be another four years before the British would threaten the North Carolina Colony again. It was a big "W" for the Revolutionary cause.

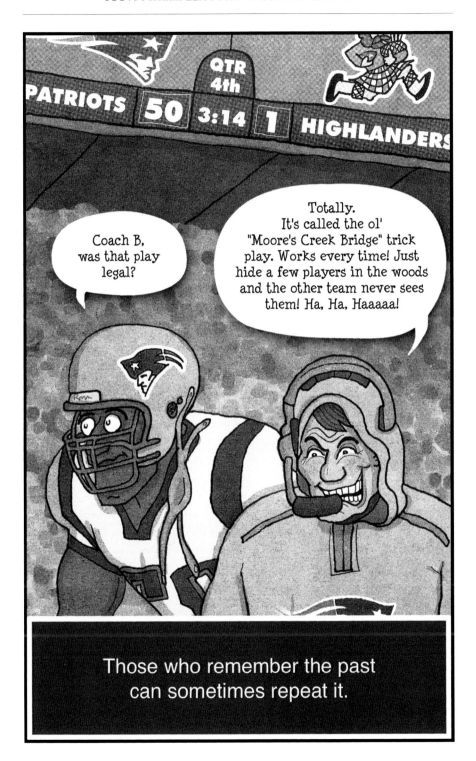

1776: THE HALIFAX RESOLVES

Apart from the Battle of Moore's Creek Bridge and a few skirmishes with the Cherokee on the western frontier, 1776 was relatively quiet on the warfront. Now the focus shifted back to the politicians.

The Fourth Provincial Congress of North Carolina (the body of elected Assembly members from the voting public), gathered at Halifax on April 4, 1776. Bolstered by the events at Lexington and Concord and the overwhelming victory at Moore's Creek, the delegates were of one accord: independence from Britain!

To clarify their position and to buoy a consensus among the colonies, the Provincial Congress elected a committee to draw up a formal statement of intent. On April 12, the committee submitted the Halifax Resolves. The resolves directed the future delegates of the Continental Congress (North Carolina would send three) to support the push for independence and gave the Carolina legislature the right to produce a state constitution. Support for the resolves were unanimous, with eighty-three delegates adopting their approval.

The Halifax Resolves were the first official statements by any colony that called for a unified colonial independence from Britain. And unlike the bogus Mecklenburg Declaration (the "Mec Dec," as it came to be fondly remembered in the abbreviation-friendly twentieth century), the documents were officially filed away for posterity.

The resolves were submitted at the Second Continental Congress in May 1776, and although they did not empower the three delegates to present a resolution for independence (Virginia would take this step), they explicitly gave William Hooper, Joseph Hewes and John Penn the directive to vote for independence (confirming our suspicions, the three men's names are inscribed on the 1776 Declaration of Independence).

In honor of the Halifax Resolutions and the North Carolina men who approved them, April 12, 1776, was also emblazoned on the North Carolina state flag in 1861—uncomfortably resting below the implausible Mec Dec memorial.

In 1965, Senator Emmett Brown and Representative Marty McFly suggested a minor change to the NC state flag. Their co-sponsored bill, Scuttle the Mec Dec, failed by a margin of 168–2.

1776: First Constitution

To reinforce their poor standing with the British government and to began the process of self-government, on December 18, 1776, the delegates of the Fifth North Carolina Provincial Congress established a state constitution. After forty-two days of wrangling, debate and hand wringing, the delegates resolved to pursue the following course:

- The power of government would be in the hands of the voting public and their elected officials, who served in either the House of Commons or the Senate.
- The voting public would consist of twenty-one-year-old white men who owned at least fifty acres (required for Senate voting) and twenty-one-year-old non-slaves who had paid the previous year's county taxes (required for House of Commons voting).
- One Senate delegate and two House of Commons delegates would be elected annually per county. This group of distinguished gentleman, required to own at least three hundred acres of property to be elected, would be called the General Assembly.
- The General Assembly would elect judges and officials to maintain justice, appoint generals and officers of the state militia and elect a governor (with limited authority) for a term of three years.
- No elected official could deny the existence of God or the truth of the Bible and the Protestant religion.

The constitution ensured that a wealthy, landowning aristocracy of men governed the state—a carryover of British ideals and sentiments—and similarly British, the state would not dictate the religion of elected officials, as long as said officials agreed to be religious in some Protestant fashion (which sounded strangely contradictory). And if one were Catholic, one might as well forget politics.

North Carolina's constitution, although democratic in its intent (endorsing a voting public), created one large, undemocratic provision: three hundred acres of man land. This policy ensured two conditions for North Carolina's future: 1) political power would be reserved for men who were wealthy—conditions most likely met in the eastern part of the state—and 2) North Carolina would NOT be a true democratic society until a new constitution was formulated, ninety-two years later.

1777: WHAT WAR?

As the Revolutionary War progressed, North Carolina would once again find its geography playing a pivotal role in the lives and attitudes of its inhabitants. With the coastline offering limited access to shipping, a Piedmont crammed with dense forests and a mountain region offering thickets of **rhododendron** and steep terrain, North Carolina gave the British little incentive to bother with it.

For many North Carolinians, this was fine. The "don't mess with us" attitude (augmented with "and we won't mess with you") seemed to apply here. While boasting a fine batch of loyal Patriots and waffling Loyalists, North Carolina would come to represent the least involved state of the Revolution—only 7,800 soldiers volunteered to fight in the Continental army for the entire war, the fewest per capita of any colony. Once a new Patriot governor had been elected (Caswell of Moore's Creek fame) and a new state constitution had been adopted, the new North Carolina government seemed content to sit back and observe. Beyond encouraging every able-bodied man to sign up for the army, little energy was expended to aid the war effort. Independence suddenly felt like "a given."

Although, in retrospect, this lackadaisical approach seems slightly contradictory to the high ideals and impassioned resolves of Carolina politicians, many constituents were glad to move on with their lives. For some, this new phase of political quiet created an imagined "our-problems-are-over" atmosphere. Taxes temporarily evaporated, law enforcement became lax and, most glaringly—thanks to the Battle of Moore's Creek and geography—the British were nowhere to be found. For those who did volunteer to fight, most of their service took place in other colonies. It would be four years before the British returned to North Carolina borders.

The ethereal, Revolutionary quiet was offset in other parts of the state by a spate of skirmishes between independent mobs of Tories and Patriots—wreaking havoc on families and personal property. Not unlike a vengeful street gang, a few Carolinians took the opportunity of war to settle old scores, steal property or vent their anger on opposing political enemies. This behavior would resurface eighty years later during the Civil War.

For the time being, North Carolina's new independence had ushered in a temporary age of government-free, Wild West living. For some, this felt reasonably good. To others, it was a hellish nightmare. Thanks to Cornwallis and the **Overmountain Men**, the era was short-lived.

Vintage North Carolina postcards
from the Revolutionary War.

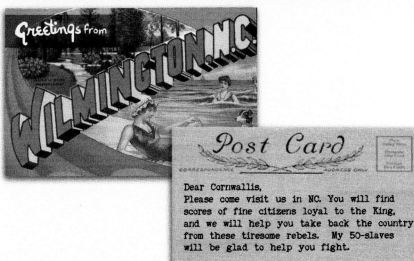

Dear Cornwallis,
Please come visit us in NC. You will find
scores of fine citizens loyal to the King,
and we will help you take back the country
from these tiresome rebels. My 50-slaves
will be glad to help you fight.

Sincerely,
Master John Brunswick

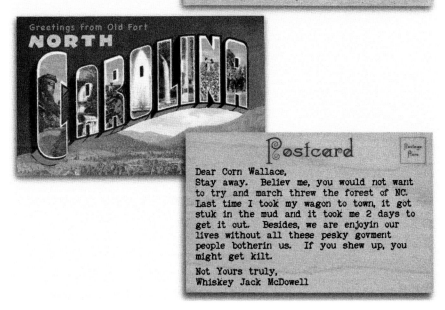

Dear Corn Wallace,
Stay away. Believ me, you would not want
to try and march threw the forest of NC.
Last time I took my wagon to town, it got
stuk in the mud and it took me 2 days to
get it out. Besides, we are enjoyin our
lives without all these pesky govment
people botherin us. If you shew up, you
might get kilt.

Not Yours truly,
Whiskey Jack McDowell

1781: THE WAR RETURNS—
THE BATTLE OF GUILFORD COURTHOUSE

On a mission to "end this bloody war before I go bonkers," Lord Cornwallis headed the southern campaign of the British military strategy. Informed that the southern colonies contained a great number of Loyalists, in 1778 Cornwallis began rounding up these Tories to help him overrun Georgia, the Carolinas and Virginia.

After subduing Savannah, Cornwallis captured Charleston and then soundly defeated the Patriots at Camden. With South Carolina in his grasp, he headed into North Carolina hoping to defeat a large Patriot force led by Nathanael Greene. Following a strategy of avoidance, Greene led Cornwallis on a wild goose chase through the backcountry. Hoping to pin Greene down, Cornwallis moved his main force toward Charlotte and sent a detachment of Loyalists, commanded by Patrick Ferguson, westward to protect his flank. Learning that Ferguson was coming their way with a large force of Tories, hundreds of backcountry woodsmen from west of the Appalachians (Overmountain Men), raced to meet him. Catching up to the Loyalist militia encamped at Kings Mountain, South Carolina, the Patriots' surprise attack completely devastated the Loyalist force, killing Ferguson and capturing all who weren't killed in the battle.

After losing 1,200 of his men in the sixty-five-minute Battle of Kings Mountain, Cornwallis became unsettled (he was "going bonkers"). He cautiously continued north and finally caught up with Greene at a small North Carolina town called Guilford Courthouse. On March 15, 1781—although outnumbered more than 2 to 1—Cornwallis attacked the Americans and eventually won the field as the Patriots retreated after ninety minutes of battle. The victory cost Cornwallis a quarter of his men. Sufficiently weakened, he gave up the chase and chose to retreat to Wilmington for rest and resupplies. When the victory became known in England, British politician Charles Fox sarcastically remarked, "Another such victory would ruin the British army."

The Battle of Guildford Courthouse forced Cornwallis to reconsider his tactics. Abandoning his efforts in North Carolina, he traveled north from Wilmington and took up residence in Yorktown, Virginia, where he hoped to pummel the Americans. As you may recall, his strategy didn't work out so well—with his surrender to George Washington on October 18, 1781, the war was all but over. North Carolina had proved pivotal at the beginning, and end, of the American Revolution—not so much in between.

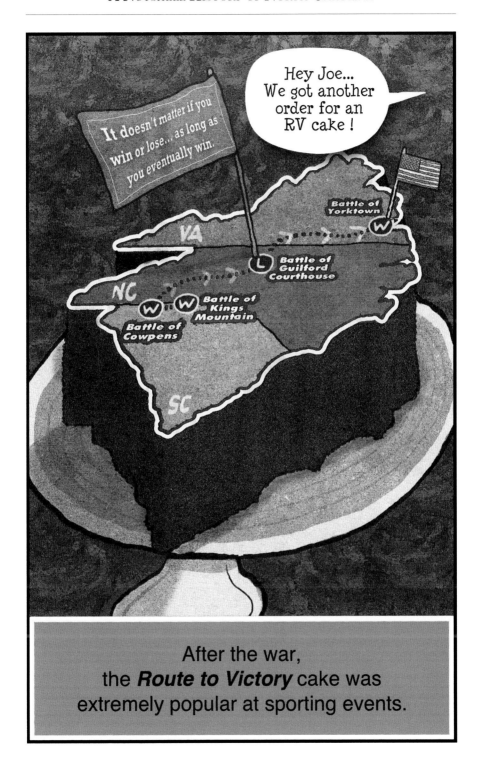

After the war,
the *Route to Victory* cake was
extremely popular at sporting events.

1784: FRANKLAND

After the Revolutionary War, with east and west factions of the Carolina Colony having united to fight the British, we might have hoped that past grievances would have been deposited in the Dumpster of Former Sour Grapes—but alas, this was NC! What happened next will stand as testament to the independent spirit of Carolinians—and the power of old disputes.

The newly formed United States of America needed cash. Many states chose to give up a portion of their western lands as payment toward the collective national debt. The American Congress then sold the land to pioneers, who settled the land and eventually created new states.

Eastern NC folk were eager to donate western lands on the logic that western NC folk were a liability—a drain on their tax dollars and requiring further protection from the Cherokee. Western NC folk wanted to create their own new state, unyoked from the burden of the self-centered easterners; this meant, for different reasons, also giving western land to Congress. As it happened in 1784, the NC legislature voted to cede all western lands to Congress. This would have been good news for most Carolinians, but within six months, the eastern-dominated legislature, regretting its decision to give away *all* those resources, chose to rescind its offer. Directly on the heels of the American Revolution, another fight was brewing in North Carolina!

Western settlers were indignant about the revoked decision. Rather than abide by the ruling, in 1784, western leaders declared themselves independent and founded the new state of Frankland (meaning, "free land"). Ten months later, in a judicious attempt to make a legitimate case for statehood, the new legislature of Frankland changed the spelling to Franklin (in honor of Benjamin Franklin), elected a governor, surveyed boundaries and petitioned Congress for statehood. From here, things went downhill.

Congress did not approve the petition. Indian attacks proliferated, and Franklin sought protection by petitioning Spain for help. NC troops were sent in to establish order. The governor of Franklin (John Sevier) was arrested, three people were killed in the confusion—and the rest is Franklin history. Franklin existed for almost five years, but without official backing, it eventually shriveled up into a bad idea. Years later, John Sevier would be pleased to learn that all of the Franklin territory had became part of Tennessee, the sixteenth state of the Union.

Choosing a name for the new state was a delicate matter.

1789: Admitted to the Union

You would have thunk (North Carolina colloquialism) that with North Carolina being the first state to suggest independence from Britain (Mecklenburg Resolves), it would have been the first state to adopt the US Constitution. But you would have been obtusely wrong. Haven't you learned anything about North Carolina?!

When the proposed US Constitution was first submitted for review to the Hillsborough Convention in 1787, the east and west factions, as always, clashed. The differences between the two could be best described by the two main political parties of the day: Anti-Federalists and Federalists. Anti-Federalists (the western faction) objected to the Constitution's strong executive powers and its far-removed federal officials, who would be unaccountable to the states. They were opposed to the power Congress would possess to levy taxes and had concerns about the lack of personal liberties and protections from a large federal government. Federalists (the eastern faction) wanted just the opposite: a strong central government; the ability to raise troops; a stable, centrally controlled economy; and a federal system of courts.

When these two ideologies gathered in Hillsborough for a discourse on the US constitution, for the first time in North Carolina history the tables had been turned: western representatives outnumbered eastern by more than two to one. Owing to the large number of Anti-Federalist delegates, when the time came to approve the US Constitution, North Carolina voted a big N-O. By the end of 1788, eleven states had been admitted into the Union—and North Carolina was not one of them.

At the next convention in 1789, this time held in Fayetteville, the tide changed again. In the ten-month lapse between sessions, the Federalists had been campaigning prodigiously. When delegates were elected, the Federalists won in a landslide, electing 195 out of 272 members. On November 21, 1789, a Federalist-dominated convention voted to accept the US Constitution, and North Carolina became the next-to-last state to be accepted into the Union (Rhode Island would be last). The easterners had won again.

Curiously, North Carolina would become the last state to withdraw from the Union at the start of the American Civil War (see "Secession").

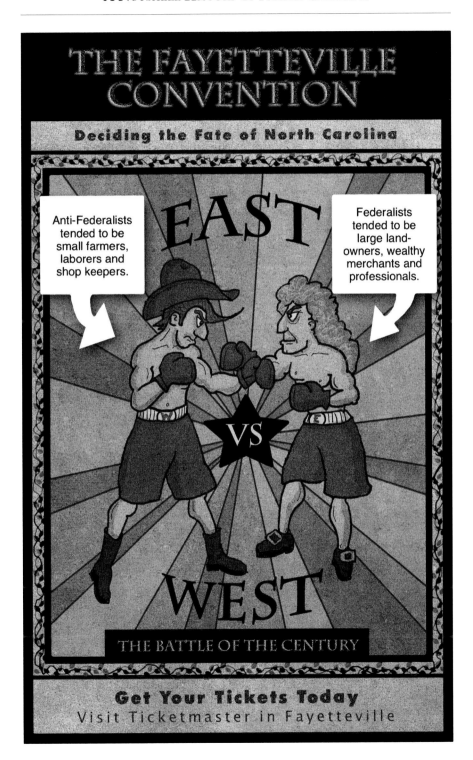

1792: THE STATE CAPITAL

With the fate of the young state decided, it soon became evident that the legislature required a permanent resting place for conducting government affairs. Prior to this realization, North Carolina had employed three capitals—Bath, Edenton and New Bern—and a random collection of legislative hideouts, which also included Hillsborough, Tarboro, Fayetteville and Smithville. Owing to population centers, wartime hazards and trade routes, these places had become convenient towns for politicking.

As state capital choices were being debated (it took four years to finalize a hotly contested decision), the population of North Carolina had grown to about 350,000, and western expansion had slowly moved population centers with it. For many politicians, Fayetteville was the obvious choice. Named in honor of the Marquis de Lafayette, a French military hero who aided the Revolutionary cause, the town had successfully hosted the state convention that ratified the US Constitution, and it boasted an urban center bursting with merchants, food establishments and navigable roads.

For reasons slightly vague (some historians say legislators wanted to build the state capital near the state university), the Assembly eventually cast a very divided vote to develop a barren tract of wilderness sixty-five miles north of Fayetteville—property that boasted a large assembly of trees and a tavern. Purchasing a one-thousand-acre plot, the legislature—in a moment of British nostalgia—elected to call the new, nonexistent town, Raleigh (if you recall the Lost Colony, then you'll conveniently know why it chose the name).

Today, Raleigh is one of the few American cities that was designed and built specifically to serve as a state capital. Founded in 1792, it would be meticulously laid out in a grid pattern, with the Capitol Building located in its center. Currently, Raleigh is the second-largest city in North Carolina, with about half the population of Charlotte.

1795: FIRST PUBLIC UNIVERSITY IN AMERICA

At the end of the Revolutionary War, there were eighteen colleges in the United States of America, all of which were private schools with pricey tuitions. In 1789, North Carolina legislators made a strategic move to create the first state-supported public school in the United States.* Originally chartered at the Fayetteville Convention, the University of North Carolina opened its doors to students on January 15, 1795, in Chapel Hill.

Though the campus consisted of a two-story brick building and an unpainted shack for the presiding professor, the opening day ceremony featured the governor of North Carolina, the board of trustees and—drum roll, please—no students. Three weeks later, James Hinton arrived to be the first, and only, student of the university. On February 12, classes commenced, and within a few short weeks, James would be joined by a total of forty-one students. For the record, in 1795, tuition for one academic year at UNC was sixteen dollars.

In 1798, James and six other students became the first graduates of the University of North Carolina. Along with James Hinton, some of UNC's more famous graduates included Thomas Wolfe (novelist), James K. Polk (president), Andy Griffith (actor), Charles Kuralt (TV journalist), Jeff MacNelly (Shoe comic strip author), Caleb Bradham (inventor of Pepsi) and, of course, that guy who played basketball, Michael Jordan (millionaire).

*It is worth noting that three states claim bragging rights to the "Oldest Public University in America": North Carolina, Georgia and Virginia. Although all claim a piece of the pie (and boldly do so in their marketing materials), it clearly depends on your academic interpretation. The University of North Carolina claims supremacy by being the first public school to provide classes and graduate students. The University of Georgia claims domination by being the first state, in 1785, to charter a public school. UGA did not offer its first classes until 1801 (Georgia's claim seems a bit lame: "OK, so you wrote down the idea four years before NC, but you didn't do anything about it for sixteen years?"). Finally, the College of William and Mary, in Virginia, claims ascendancy by virtue of being founded as a private school in 1693 and converted to a public school in 1906 (this claim doesn't seem lame; it is lame). Naturally, to uphold academic integrity, North Carolina wins.

1799: FIRST GOLD

Our next story is one you might have difficulty believing. Despite your misgivings, be assured it is the gospel truth.

During the American Revolution, and many other English wars, it was common for the British to hire mercenaries to assist in their efforts. Consequently, there were large numbers of Hessians (German soldiers) fighting within British ranks. One such soldier went by the name of John Reed (using an Anglicized version of his last name, which was probably something like Reidenbokenscmidt). Reed deserted his battalion in Savannah and made his way into the backwoods of North Carolina. Settling twenty-five miles east of Charlotte, he married and raised a family.

In the spring of 1779, John's twelve-year-old son found a large gold-speckled rock while he was fishing in nearby Little Meadow Creek. After his son dragged the seventeen-pound stone home for his dad to examine, John was unable to identify it—and the bizarre rock was relegated to doorstop duty for the next three years.

Out of curiosity, Reed finally hauled the rock to a jeweler in Fayetteville, who correctly identified it and offered to melt it down into pure form. Agreeing, John later returned to discover that his doorstop had magically turned into a six-inch bar of gold! Not fully grasping the value of his new doorstop, Reed offered to sell it to the jeweler for $3.50. The jeweler, being of less-than-forthright character, paid the naïve Reed and then quickly sold the bar for $3,600 in cash. OUCH!

Reed soon discovered the error of his ways and began further diggings along the creek. He eventually signed on several business partners to help in the endeavor, and his diligence led to the appearance of a few more gold-speckled doorstops. He would go on to become a wealthy, illiterate owner of two thousand acres and a dozen or so slaves, whom he utilized in the mining business. Needless to say, Reed's discovery brought a number of amusing characters to North Carolina and led to a full-fledged mining boom, boasting over fifty mines and twenty-five thousand workers, in and around Charlotte.

In 1848, by the time the mines and creeks of North Carolina had run out of gold doorstops, America's first gold rush was over. North Carolina would lead the nation in gold production until the great California migration.

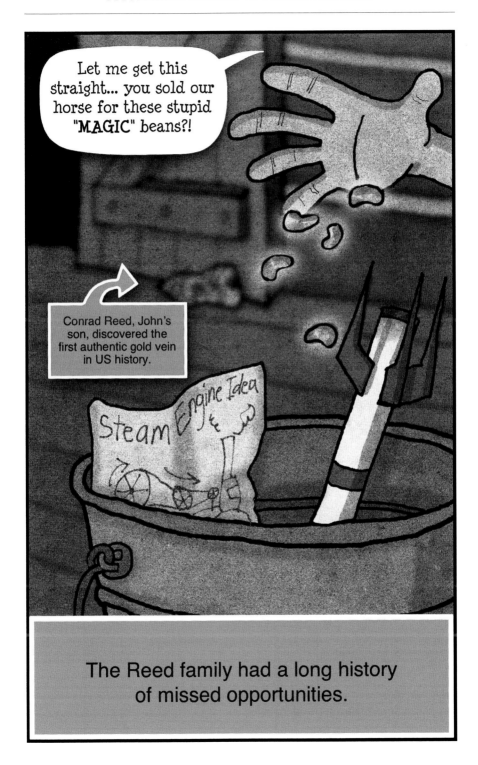

1804: THE WALTON WAR

After all the years of pushing and shoving to grab land for lumber, tobacco, rice or gold, this next story seems fairly peculiar to North Carolina. It involved a piece of land that nobody wanted—that is to say, no government wanted it.

According to the record books, there were about eight hundred settlers living on a narrow strip of land twelve miles wide, bordering on North Carolina, South Carolina and Georgia. In this particular territory, the official boundaries of North Carolina and Georgia were mysteriously vague, so as it happened, no state government currently claimed (or wanted) oversight of the territory. Consequently, life here was moderately turbulent. To put it another way, no judicial authority, sheriff or militia would bother to settle a civic difficulty if anyone happened to experience one. Indian attack? Deal with it. Friend murdered? Solve it yourself. Neighbor cuts down your prized hemlock tree? Eat his prized hog.

All this confusion and disorder led the people of the twelve-mile tract to appeal for help, believing that Georgia might be best suited for the job. In 1803, Georgia opted to assume responsibility for the area and annexed the entire region as Walton County. This was all fine and good, until 1804, when Georgia innexplicably decided to collect property taxes. As history repeatedly chronicles, people are not fond of taxes, especially from out of state. Settlers who had received their land grants from North Carolina refused to pay taxes to Georgia. Meanwhile, a representative from North Carolina showed up to collect taxes as well—and of course, Georgia folks wouldn't comply either. Adding to this confusion, a disconcerting question began to surface: "What if I lose my land to the opposing team?"

A crisis developed when feuding factions began shooting at each other and attempting to physically remove certain tax officials from their property. In the final blow (which was literally a final blow), a North Carolina constable was killed by a blow to the head. Officials from Buncombe County, the neighboring North Carolina territory, responded decisively, sending in a militia unit to arrest the perpetrators and quell the masses. The conflict came to be called the Walton War, which terminated when a surveyor finally settled the boundary dispute, confirming that the property in question did, indeed, belong to North Carolina.

Today, the Walton War is a unique part of North Carolina history—the only war fought between North Carolina and Georgia and resolved by a simple, peace-loving surveyor.

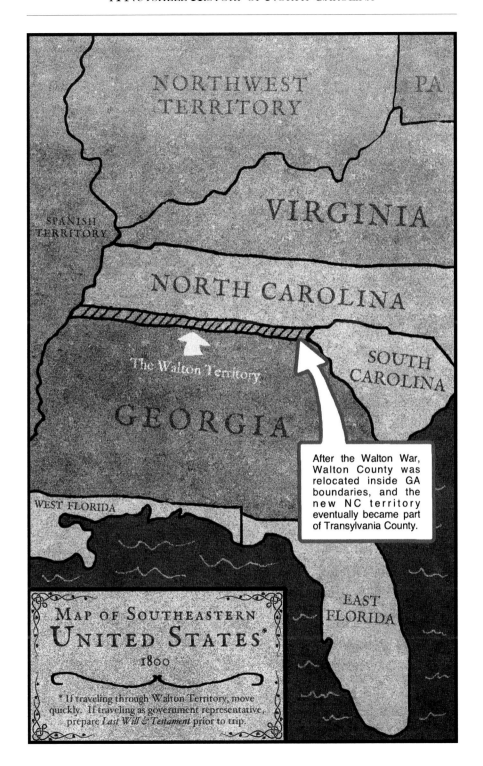

PA

NORTHWEST TERRITORY

SPANISH TERRITORY

VIRGINIA

NORTH CAROLINA

The Walton Territory

SOUTH CAROLINA

GEORGIA

After the Walton War, Walton County was relocated inside GA boundaries, and the new NC territory eventually became part of Transylvania County.

WEST FLORIDA

EAST FLORIDA

MAP OF SOUTHEASTERN UNITED STATES*
1800

* If traveling through Walton Territory, move quickly. If traveling as government representative, prepare *Last Will & Testament* prior to trip.

1812: DOLLEY MADISON AND THE WAR OF 1812

There should come a time in every history book when serious academic inquiry yields to sublime, nuanced trivia. Therefore, without apology, the following story is included for its high score on the North Carolina Trivia Scale.

The year was 1812, Britain and France were at war and due to pesky trade blockades and unprovoked attacks on American merchant ships, the new American nation had chosen to declare war on Britain. All too glad for the opportunity to seek revenge, Britain promptly stormed North America in hopes of destroying its resources and embarrassing its president. By 1814, a significant blow was forthcoming.

Having overcome American forces around the Washington capital, British forces advanced on the uncompleted White House with the intent of burning it to the ground. As President Madison and his cabinet gathered up important papers before they skedaddled, the president's wife—Dolley Madison, a well-liked socialite and hostess—managed to secure valuable presidential memorabilia, including a prized painting of George Washington. For this effort, she became a national heroine.

At the completion of the war (a stalemate at best), Dolley returned her treasures to the burned-out White House and, after its restoration, resumed her entertaining. Born into a Quaker family in New Garden, North Carolina, Dolley would be remembered for her savvy rescue and her famous dinner parties. She had a particular fancy for cinnamon cakes, gingerbread and ice cream.

And now for the nuanced trivia. In 1937, a baker by the name of Roy Nafziger had developed a fascination with Dolley and her high-class snacks. Using the tagline "Cakes and pastries fine enough to serve at the White House," Roy created the Georgia-based Dolly Madison Bakery (dropping the "e" for ease of spelling), which produced such upscale favorites as Zingers, Fruit Pies and Cinnamon Coffee Cakes. Other vendors would eventually create a Dolly Madison Ice Cream and Dolly Madison Popcorn.

Thanks to Dolley Madison, North Carolina can proudly claim some sort of ownership to the ubiquitous Zinger and a disheveled painting of George Washington. On a historic note, Madison County, North Carolina, is named after Dolley's husband, James Madison, the fourth president of the United States.

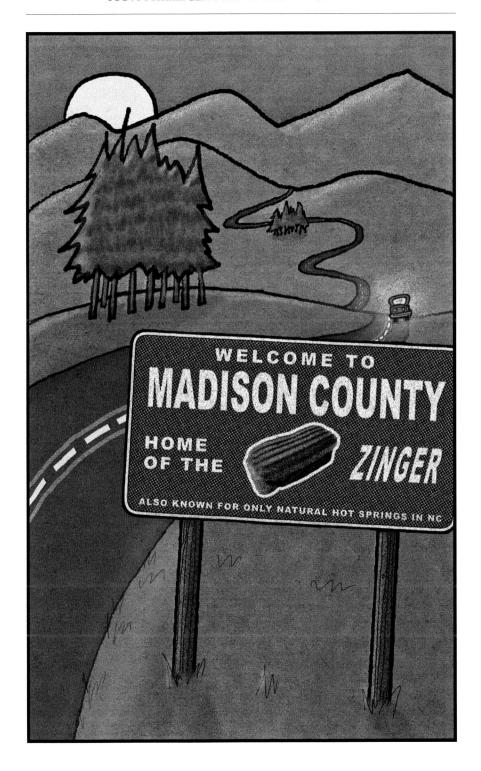

1825: THE RIP VAN WINKLE STATE

And now we reach a sleepy reality of North Carolina's past. Despite all the hubbub of exploration, settlement, agricultural development, political action, independence claims, wars, statehood and discoveries of gold, by 1825 neighboring states had awarded North Carolina the derogatory nickname of "the Rip Van Winkle State." Recalling the story of Rip, you may remember him as the lackadaisical farmer from Washington Irving's tale who wandered off into the mountains and fell asleep for twenty years, awakening to find the world had rushed on without him. Based on the North Carolina legislature's inability to build roads or create growth-producing economic policies, the lack of funding for public schools and the general ambivalence of the populace, the dubious title seemed fairly accurate. By 1825, North Carolina had fallen asleep, content to enjoy its mediocrity.

One lawyer from Hillsborough described the Carolina populous in this way: "I had no idea that we had such a poor, ignorant, squalid population, as I have seen. The mass of the common people in the country are lazy, sickly, poor, dirty and ignorant." Another traveler commented, "No state has done as little as North Carolina to promote education, science and the arts."[4]

Alas, it was a sad judgment. From its unsociable shoreline to its pleated topography, North Carolina had always welcomed those who appreciated isolation—defined by many Carolinians as a freedom from government influence, whether that came in the form of taxes, navigable roads or mandated education. Unable to shake its past and its terrain, over half the populace could neither read nor write—and were "just darn fine" if things stayed that way. While small cities and towns offered some culture and civility, that "don't mess with us" attitude prevailed across much of the state.

These backward conditions led to the Great Exodus of the 1800s. Thousands were simply fed up with difficult trade routes, poorly maintained roads, an abundance of unnavigable and un-crossable waterways, a distaste for public education and an apathetic government to boot. Between 1815 and 1840, over one-third of North Carolina's population migrated elsewhere—a huge loss of labor, economic growth and progressive ideas. It would take over a century for Carolina to recover.

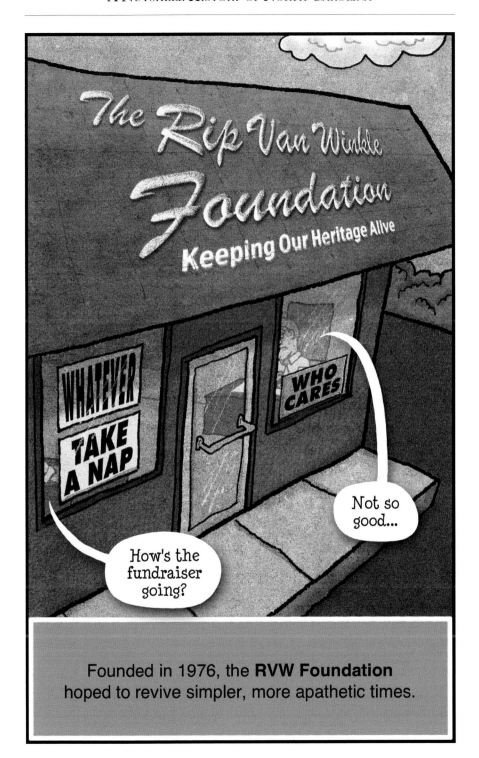

1826: Levi Coffin and the Underground Railroad

If we were to rewind the clock of time, carefully reviewing circumstances and events that formed a particular person's values and interests, it could be said that Levi Coffin had been made for this moment. The moment, in this case, was the smuggling of slaves to freedom. The man who was being prepared for this moment received his apprenticeship in North Carolina, a southern slave state.

Levi Coffin was born in Guilford County, near present-day Greensboro, North Carolina. As the son in a Quaker family, Levi was taught to abhor slavery. His experiences in North Carolina, specifically those involving the brutal treatment of slaves, would fortify his parents' teaching. Describing an encounter with a slave at age seven (as recounted in his autobiography), Levi said he asked the poor man why he was shackled. The slave responded, "To keep me from escaping and returning to my wife and children."[5] These episodes burned a hole in Levi's soul—a hole that could only be plugged with the freeing of slaves.

By the age of fifteen, Levi was helping his family hide runaway slaves on the farm and exploring options for their escape to safety in northern states. With the Fugitive Slave Act in full force (a federal law allowing slaveholders to recover their escaped slaves), Quakers became suspect for their unusual night activities. By the 1820s, Quakers were being told "where to go" (Hades) and "how to get there" (at the wrong end of a rifle) by a growing number of suspicious slaveholders. As persecutions thickened, Quakers began to leave North Carolina in antislavery droves, relocating to the free states of Ohio and Indiana.

In 1826, with his apprenticeship in slave escape complete, Coffin would move with his wife to Indiana, committing their lives and livelihoods to the freeing of slaves through the development of the **Underground Railroad**. Coffin would go on to accomplish many courageous and self-sacrificing feats to assist former slaves, but his greatest contribution was his involvement in the escape of over three thousand slaves from the southern states.

In an inauspicious way, North Carolina trained one of abolition's greatest heroes.

Young Levi often misquoted the Scriptures to sidetrack slaveholders.

1829: ANDREW JACKSON

In 1829, Andrew Jackson became the seventh president of the United States and the first and only president to be claimed by two states. Verifying this confused state of affairs, today you will find two edifices commemorating Andrew Jackson's birthplace: Andrew Jackson State Park in Lancaster, SC, and, 3.1 miles away, a stone monument declaring Jackson's birthplace on a lonely dirt cul de sac in Union County, NC.

The discrepancy in historical markers is significant, as the two states have bickered over ownership of Jackson for over one hundred years, resulting in reams of historical debate, a monument-raising frenzy (there are currently seven markers in a ten-mile radius, two of which are in NC) and a stream of revenue flowing toward the especially adamant state—SC, which boasts a state park complete with birthplace marker; replica homestead; schoolhouse; living history events; a Jackson museum; a life-size, horse-riding Jackson statue; a campground; hiking trails; and a man-made lake stocked with fish. Theoretically speaking, ownership of a US president's birthplace could be a lucrative business.

The controversy rages on because Jackson's exact birthplace remains vague. Returning home from the funeral of her husband, who died in a logging accident, Jackson's mother went into labor and delivered "Old Hickory" (his military nickname) somewhere near the NC-SC border—at a sister's house along the route (NC) or at a brother-in-law's house in Lancaster (SC), where he was raised. Clouding the event are disputed state boundaries, which were not exactly clear at the moment of birth. To make matters incontrovertibly worse, today both NC and SC capitals boast towering statues of their favorite presidential son (for SC, the claim is particularly poignant, for Jackson was the only president it produced; North Carolina proudly claims three presidents).

For our purposes, it will suffice to say that Andrew Jackson attended law school in NC, then established his practice in Jonesborough, in what would eventually become part of Tennessee. He would later claim Tennessee as his home state, build a large plantation there and accept military appointment in the militia. He gained national prominence in the victory over the British at New Orleans (War of 1812), gained the US presidency for two consecutive terms and was responsible for initiating the despicable government policy of Indian removal, leading to the removal of the Cherokee from North Carolina, his former home state.

1830: Cherokee Land

Although the Cherokee had signed treaties with the American government, ensuring their right to what was left of their land, settlers from Georgia, Alabama and North Carolina continued to push the limits of decency. In 1830, with the discovery of gold on Cherokee lands, white incursions became threatening. The Cherokee had made every possible attempt to adapt to the growing hostilities—adopting white customs, embracing Christianity and white methods of agriculture and establishing schools to learn English. The Cherokee were perhaps the most exemplary tribe of Native Americans in their efforts to coexist with the white man. But ultimately, it was to no avail; the presence of gold, and President Andrew Jackson, made sure of it.

John Ross, the Cherokee chief, had eloquently put the plea of the Cherokee before Congress: "We appeal to the magnanimity of the American Congress for justice, and the protection of the rights, liberties, and lives of the Cherokee people. We claim it from the United States, by the strongest obligations, which imposes it upon them by treaties; and we expect it from them under that memorable declaration, 'that all men are created equal.'"[6]

In 1835, President Jackson responded with a new treaty, which curtly suggested that the Cherokee, with their "peculiar customs…could not flourish in the midst of a civilized community."[7] The treaty required immediate removal to Indian Territory (Oklahoma). The US Senate approved the hotly contested treaty by a margin of only one vote. Twenty Cherokee, a minority faction of the tribe, signed the despised treaty, and it was a done deal. In due course, many of the treaty signers were assassinated by the Cherokee for their duplicity.

In 1838, General Winfield Scott was ordered to "make good" the terms of the treaty. Forcing the Cherokee to leave behind homes, goods and memories, they were rounded up in detention camps and allowed to bring only the clothes on their backs. During a harrowing 1,200-mile, six-month winter journey, approximately one-fifth of the Cherokee Nation died en route to the Indian Territory. The Trail of Tears, as the Indian removal came to be described, would become one of the most shameful acts of the US government perpetrated against Native Americans. As one soldier of the removal aptly stated, "Covetousness on the part of the white race was the cause of all that the Cherokees had to suffer."[8]

...with their pea-culiar customs... could not floresh in a c-v-l... c-v-i-l... c-e-v-e-l-i-s...

Jackson's detractors, who considered him an uneducated, tactless yahoo, nickednamed him the "Jackass." The Democratic Party would eventually adopt Jackson's jackass, caricatured in the media, as its official mascot.

Sec-ra-tary of State!! I'm writin' this here new treaty. How do you spell SIVIL-IZED?

1831: NAT TURNER AND SLAVERY

At this juncture in history, we might as well face it: North Carolina persisted in its backward behavior. The east-west sectionalism continued to plague the state, clogging up progressive legislation with divisive logjams. While the state economy tanked, needed improvements to local and state infrastructures were neglected. Public education was predominately zilch. Homesteaders were leaving for greener pastures, Quakers were leaving for slave-free states and slaves were just looking to leave, period.

At this troubled moment in North Carolina history, Nat Turner arrived on the scene. Born a slave in Southampton, Virginia, twenty miles from the North Carolina border, Reverend Turner felt called by God to bring southern slavery to a violent end. Enlisting the help of fellow slaves, on August 22, 1831, Turner unleashed a twenty-four-hour terror on white slave owners. After murdering his white owner and family, Turner's band of mutineers attacked eleven more plantations, killing a total of fifty-five men, women and children. As the angry slaves headed north, they were intercepted by a large Virginia militia, which proceeded to ruin their plans. Many of the slaves were killed, taken captive and ultimately hanged. Although Turner avoided capture for two months, he, too, was eventually caught, tried and hanged.

In the ensuing fear of further slave revolts, white mobs in and around Southampton wreaked their vengeance on suspected slaves. Estimates put the killings between two and three hundred slaves, and the violence spilled over into North Carolina, all the way to Wilmington. White mobs attacked and killed innocent slaves; slaves were falsely accused, arrested and executed; and merciless beatings and tortures were carried out against law-abiding slaves who were somehow considered part of the insurrection.

Turner's Rebellion had the opposite intended effect on southern states. Virginia and North Carolina legislatures imposed stricter codes and harsher penalties for whites and blacks who did not support the suppression of the slave population. These restrictions included a maximum $200 fine for any white person who tried to teach a slave to read or write and up to thirty-nine lashes for a slave caught in the same act. Other laws made it illegal for slaves to preach, carry any sort of weapon or even to marry.

As northern abolitionists watched these reactions unfold, the perceived morality gap between free and slave states widened substantially. The eradication of slavery, Turner's ultimate objective, took on a greater sense of urgency in slave-free states.

1835: REVISED CONSTITUTION

As a consequence of the provisions of the North Carolina constitution, in 1830 the voting population of eastern North Carolina (consisting exclusively of men with property) made up less than 10 percent of the total white population. Yet this 10 percent elected the majority of legislators for the entire state. The legislators they chose tended to represent their interests—a wealthy aristocratic few. These undemocratic lawmakers, as we have learned, had little interest in developing roads, schools or services for the "common peasants" of North Carolina.

As frustrations mounted between the well-represented eastern populace and the poorly regarded western populace (déjà vu), the push for legislative dominance became a flat-out political war. The following example illustrates the shenanigans.

By 1835, the western population (west of Raleigh) outnumbered the eastern. To counter this dilemma, eastern politicians not only discouraged the creation of western counties but also began splitting their counties in half to ensure that eastern delegates would outnumber the west (this explains why North Carolina contains many smaller eastern counties to this day). Western advocates countered with an ingratiating scheme of their own—offering to name their proposed counties after eastern leaders, hoping the honorees would take the bait. (Ashe, Buncombe, Cabarrus, Haywood, Iredell and Macon Counties were all named in this groveling fashion.)

It all reached a boil when western delegates finally succeeded in pushing through a bill calling for constitutional reform. The ensuing Constitutional Convention sought to address east-west factions that had dominated (and inhibited) North Carolina for over one hundred years. Cutting to the chase, among other amendments, the 1835 convention managed to establish the membership of the Senate and House at 50 and 120 members, respectively; the governor was now to be elected by the populace (rather than the eastern legislature); and Catholics were no longer considered unfit for public service (good luck getting elected). Unlike the original state constitution, the amendments were subjected to a public vote, which passed only with the help of a large western populace. As to be expected, voters from western counties voted "yes" and voters from eastern counties voted "no"—and for once, population numbers mattered.

The resulting changes led to the first western-led legislature in NC history. It would dominate political decisions for the next fifteen years, bringing road improvements, railroads, public schools, state banks and a general sense of bustling industry to a neglected western North Carolina.

After 59 years of dominating the NC legislature, in a musical sense, the Beach Boys reluctantly handed the baton to the Foggy Mountain Boys.

* sung to the tune of "Fun, Fun, Fun," by the Beach Boys
** sung to the tune of "Good Ol' Mountain Dew," by the Foggy Mountain Boys

1838: Eastern Band of the Cherokee

The year 1838 appeared to mark the beginning of the end for the Cherokee in North Carolina. Were it not for an adopted white man and a renegade Indian, the Cherokee might have vanished forever from the mountains of North Carolina.

With the enforcement of the Indian Removal Act, the Cherokee had been arrested, dragged from their homes and forced to leave everything they owned to the gathering white vultures. Based on a loophole in the Treaty of New Echota, signed by President Jackson, a small band of Cherokee appeared to be exempt from the expulsion. Referred to as the Quallatown Cherokee, a white man adopted into their tribe (William Thomas) had purchased western North Carolina land in his name and provided the land for his band of brothers. With their residence falling outside official Cherokee boundaries (land the US government now claimed), the Quallatown natives seemed to be in the clear—but there remained some doubt.

For several hundred Cherokee who were being hunted down, the thought of leaving their treasured mountains drove them to desperate measures. Some families hid in the woods, others escaped the shoddy stockades where they were temporarily imprisoned and some fought back. Several Cherokee families led by Tsali—living near what is today Bryson City, North Carolina—managed to escape the soldiers who prodded them toward captivity, killing one and disappearing into the mountains. Enlisting the aid of the Quallatown Cherokee, the commanding officer in charge of the removal (Scott) promised to leave the Qualla in place and to abandon any further rounding up of fugitives if they would convince Tsali and his band to surrender. Recognizing their precarious situation, the Qualla Cherokee persuaded Tsali to yield. His execution, along with his elder brother and two sons, brought the man hunt to a close and sealed the survival of the remaining thousand or so Qualla Cherokee—and the fugitives who were still hiding in the mountains.

Today, the Eastern Band of Cherokee Indians (EBCI) are direct descendants of these North Carolina remnants, living on Quallatown land that was eventually designated a land trust by the US government (see "Cherokee Reservation"). The EBCI are the only remaining Cherokee living on native lands, comprising more than fourteen thousand Native Americans, all owing their heritage to an adopted white man and a native brother who sacrificed his life for the future of the Cherokee.

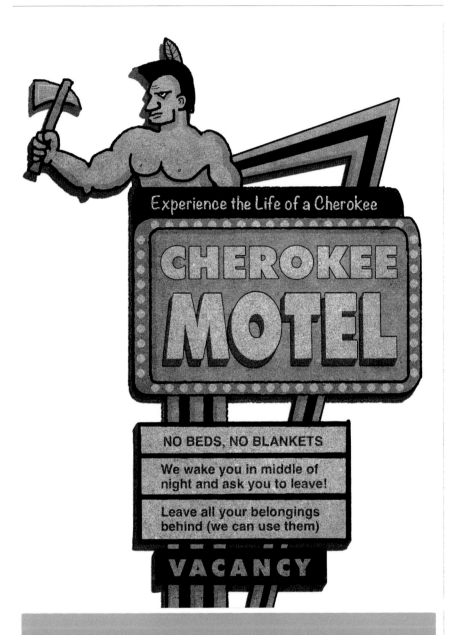

Not long after the EBCI was established, the tribe decided to build a motel for white visitors.

1839: BRIGHT-LEAF TOBACCO

And now the tobacco leaf resurfaces, as it occasionally will, into our story.

By this point in Carolina history, tobacco still held out a hopeful but anemic promise for agricultural wealth. With large slave plantations being employed by Virginia and South Carolina, North Carolina had been unable to match their prolific tobacco economies. North Carolina was further disadvantaged by its sandy soil and limited trade routes. Carolina farmers couldn't compete with the finer-quality tobaccos of its neighboring states, but what it did produce still gave the neighbors that sweet "aromatic buzz"—and so it sold in small quantities.

In 1839, due to a fluke discovery, North Carolina's tobacco fortunes would change forever. Regrettably, for a slave named Stephen—the sleepy-eyed "discoverer"—profits would never come his way. Working on the farm of Abisha Slade, Stephen had been tasked with curing a barn full of tobacco. Slade's tobacco had been cut, bundled, placed on drying sticks and submitted to a slow-burning, smoky fire that would endow the tobacco with its sweet, nicotine-laden taste. Tending the warm embers, Stephen had grown bored and fallen asleep. Waking to find his fire almost out, the quick-thinking blacksmith grabbed a few coals from his shop and tossed them on the smoldering wood. The intense heat unintentionally cured the tobacco quickly, transforming the leaves into a bright golden yellow. When his "bright-leaf" tobacco went to market, Slade's customers raved over the unique taste of his product.

Within a decade, bright-leaf tobacco had become the new cancer-producing craze. With this home-grown discovery, North Carolina farmers were soon growing tobacco on anything that could yield a plant—sandy soil, rocky soil, backyards, hillsides or mountaintops. Almost overnight, North Carolina farmers began looking to tobacco to build their empire.

BRIGHT LEAF TOBACCO

In 1839 on a farm in this area, Abisha Slade perfected a process for curing yellow tobacco.*

* His slave Stephen actually discovered the process, but he really didn't have anything to do with its success.

Occasionally, historical markers offer a subjective viewpoint.

1840: FIRST FREE PUBLIC SCHOOL

According to the North Carolina record books, in 1705 the Quakers established the first private school of "lower" education (in strictly academic terms, the twelve or so years of study including primary, elementary, middle and the antithetically named "high" school). While private lower schools would proliferate across the state in the ensuing years, it would be another 135 years before the first state-supported public schools opened for business. This unseemly time lapse had immense repercussions for the state and its citizens, as we shall witness in later entries.

For now, it is worth noting that once the western delegates took control of the North Carolina legislature in 1835, the desire to keep the uneducated masses in the dark began to diminish. In 1839, the legislature passed the Common School Law, providing state and local funding for public schools. The law established a Literary Fund that would provide two dollars for every school-designated dollar of local taxes. Interestingly, the state Literary Fund was fed by bank stocks, sales of land, license taxes and federal money received for the removal of the Cherokee (perhaps an indication of prevailing sentiments, legislators took a good chunk of the money designated for the transfer of Indians and gave it to white children instead).

The first official free public school in North Carolina opened in January 1840 in the Williamsburg community, twenty-one miles north of Greensboro. Although the name and the exact location of the school have been lost to history, it's significant to note that within six years, every county in North Carolina boasted of at least one public school: a giant step forward for a state long in the throes of wealthy, unsympathetic landowners.

1845: JAMES POLK

In 1845, North Carolina would claim another US president, James Knox Polk.

James was born in a small farmhouse ("possibly a log cabin," one source notes in Lincoln-ese fashion) in Pineville, North Carolina, near Charlotte. Born to Presbyterian parents of Scots-Irish descent, Polk's father was a slaveholding farmer who gave up on North Carolina to pursue a life of land speculation in Tennessee. Moving his family after James's eleventh birthday, the elder Polk became wealthy and was eventually selected as a Tennessee county judge. Meanwhile, the young Polk had been homeschooled until 1814 (remember, no public schools until 1840) and then headed to the University of North Carolina. Graduating with honors, Polk then traveled to Nashville, where he received his law degree and was admitted to the bar in 1820.

In unpromising fashion, James K. Polk's first law case involved defending his father—charged with public fist fighting—gaining his release for a one-dollar fine. He would go on to greater heights of notoriety, growing a successful law practice, accepting an appointment as colonel in the Tennessee militia, fulfilling five terms in Congress, serving as governor of Tennessee and reaching the presidency in 1845 with a campaign advocating slavery and westward expansion. Polk would become the only president whose home states, North Carolina and Tennessee, did not support him.

Although Polk was known for his fine oratory skills, period portraits depict Polk as a serious Addams family contender, with a sinister-looking scowl permanently etched on his face. Along with this setback, Polk would be remembered as the president who made **Manifest Destiny** the national religion, provoking a war with Mexico in order to secure western lands (as a slaveholder, he also hoped to introduce more slaveholding states). His actions would divide the nation and move it toward civil war. On a positive note, of which there were few, Polk was considered a decisive leader who strengthened the executive power of the presidency and signed the bill creating the Department of the Interior (responsible for the conservation of federal lands).

Polk's incredibly active four-year term left him exhausted and most likely initiated his spooky appearance. He died three months after his presidency ended. Polk is honored in North Carolina with a statue at the University of North Carolina and a statue at the State Capitol—where he is discreetly perched next to the keister of Andrew Jackson's horse. His plaque gushes, "He enlarged our national boundaries."

1848: Calvin's Railroad

In the summer of 1833, the Petersburg Railroad of Virginia extended its lines into NC, stopping near Halifax. Soon, the eastern seaboard of Carolina was shipping mountain loads of cotton, tobacco and rice into the state of Virginia and northward. To even the most chowder-headed businessman, it had become obvious: the railway was the path to riches. Railroad fever was officially underway in NC.

Within the next five years, every business, town and hovel wanted a railway connection, and the good citizens of NC hoped that somebody else—say, a company from Virginia or South Carolina—would make it happen. A few businessmen decided to take it to the next level. Edward Dudley, one such entrepreneur, raised enough capital to build a private railroad from Wilmington to Weldon—at 161 miles, it was the longest rail line in the world in 1840. No small accomplishment! As rail interest peaked, NC legislators took an unusual and progressive step.

The year was 1848, and assemblyman Calvin Graves decided to take one for the opposing team. The "opposing team" was a group of western legislators pushing forward the first publicly owned railroad line, aiming to connect the Piedmont with the east. Casting the deciding vote in a typical east versus west tiebreaker, Graves would take major heat from his eastern constituents, who would refuse to reelect him when they discovered the proposed railroad bypassed their district.

The railroad would cost the state $3 million, but the resulting debt would bolster the economy of NC into the next century. For sacrificing his political career, Calvin Graves was given the honor of plunging the first shovel in Greensboro soil. Four years later, the railroad opened the 130-mile distance between Greensboro and Goldsboro, and a Charlotte section was completed a few months later. Soon, NC was enjoying 223 miles of modern, publicly owned commerce.

North Carolina's new railway system would usher in a long period of industrial growth, urban development and economic progress, transforming NC like no other technological development before or since. Today, NC boasts twenty-six freight companies and five passenger companies traveling over four thousand miles of rail.

1853: North Carolina State Fair

On a scale of one to ten, in terms of significant historical events, this one probably lies at about negative seventeen. Yet even for its low score, it is enthusiastically included for the sheer volume of wonders it has produced. Consider that at the annual North Carolina State Fair, the following may be observed firsthand: human cannonballs, extremely large people in overalls, hideously stupid-looking hats, a juggling motorcycle driver jumping over a school bus, a pig race, a five-pound corn dog, a pumpkin the size of a small house, a herd of lop-eared rabbits vying for "Best in Show" or the beautiful State Fair Queen milking a cow. The North Carolina State Fair has become a slice of Americana, simultaneously hallmarking its agricultural brilliance and its aesthetic cheesiness. Most importantly, "The Far," as it's fondly called, is extremely fun! A short history is prescribed.

It seems that early nineteenth-century farmers faced numerous challenges; along with being mostly illiterate, many were utilizing outdated agricultural practices, struggling to find good breeding stock and lacking government agencies to improve their production. In 1852, a group of concerned citizens formed the North Carolina State Agricultural Society, with the intent of creating an annual state fair to showcase the most useful agricultural practices and to provide a venue for exhibiting and selling prime stock. With the help of North Carolina legislators and the financial support of Raleigh citizens, the society purchased fairgrounds and constructed stalls and exhibition halls. After a collective effort of hurricane proportions, the 1853 North Carolina State Fair, held in Raleigh, opened to rave reviews. Thousands of farmers attended, bringing new agricultural techniques, the latest farming equipment, livestock to sell, pies to eat and stomachs to fill.

Outdoing itself every year, the North Carolina State Fair has continued to grow and prosper, adding horse racing, shooting contests, concerts and, well, you name it. Shutting down only during the Civil War and **Reconstruction** years, the state fair has provided a unique event for educating and entertaining the agricultural community. With the addition of carnival rides, amusing attractions and overpriced concessions in the early 1900s, the state fair has become an event for one and all. Today, the ten-day-long North Carolina State Fair attracts over one million visitors annually. It stands as the state's oldest, most eccentric educational event.

1857: Elisha Mitchell and the First State Park

Humans have always been roused by comparisons—especially when disputable claims are infused with boasting and feelings of superiority. A statement like "My birdbath is the biggest in NC" is a comparative expression. This statement assumes that no one, most likely, can beat the claim, if one cared to compare. Our next story reveals the dark side of this sordid practice.

The year was 1857, and Elisha Mitchell (professor of geology at UNC) lay dead at the bottom of a small waterfall. Big Tom, a local bear hunter, had been called on to locate the missing professor, who had failed to return from his ongoing scientific obsession: to prove that NC possessed "the highest mountain east of the Mississippi River."

Elisha had been at this pressing task for almost thirty years. After numerous excursions into the Black Mountain Range of western NC, Mitchell's extensive measurements had convinced him that he and NC deserved bragging rights. In 1928, Mount Washington of New Hampshire held the title at 6,289 feet. Mitchell believed Mount Washington was a phony contender. Using a simple barometer and a few math calculations, Elisha had determined that his mountain, called Black Dome at the time, was a whopping 6,672 feet, over 300 feet higher than Mount Washington. Adding to the contention, one of Mitchell's former students (Thomas Clingman) had scrambled to a mountaintop on the NC-TN border, claiming his peak was the highest.

Both Mitchell and Clingman had turned to the press to convince the public that their measurements were correct. It quickly became an ugly contest, as each tried to discredit the other's scientific methods and general integrity. Seeking further vindication, Elisha climbed the mountain one last time in 1857 to make comparative tests. Making the journey alone, Mitchell became disoriented on the return, lost his footing in the dark and fell head-first to his death. Big Tom found him three days later, lying in a pool at the base of a waterfall.

In 1882, the US Geological Survey upheld Mitchell's claim, designating his mountain to be 6,684 feet (41 feet taller than Clingmans) and renaming it Mount Mitchell in his honor. In 1915, the NC legislature designated Mount Mitchell as the first NC state park. Today, comparatively speaking, Mount Mitchell is *the* highest peak east of the Mississippi. Elisha Mitchell, had he survived the comparing, would have been proud.

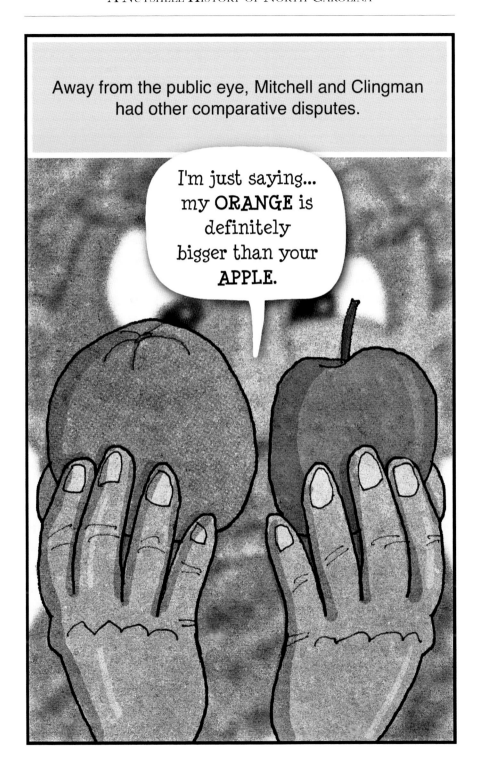

1861: SECESSION

Now we must return, unfortunately, to more serious history. With the inauguration of Abraham Lincoln as the sixteenth president in January 1861, South Carolina promptly seceded from the Union. Six more states would follow, as they perceived a threat to their Southern way of life, which relied heavily on the use of slaves to produce income.

In April 1861, as Southern troops ventured to take control of forts and troops in their respective states, Fort Sumter was fired on by South Carolina Confederates, and the war officially commenced (the North would claim the war began as an attempt to restore unity and to address the issue of slavery; the South would claim the war began as an effort to repulse those who would steal their wealth and impose their agenda).

With the attack on Fort Sumter, four more states would leave the Union, the last being North Carolina, which voted hesitantly, but unanimously, to exit. Rather than secede from the Union, North Carolina chose to completely nullify its former arrangement with the United States government, repealing its acceptance of the US Constitution and voiding the actions of its delegates in the 1789 convention. The honeymoon was over. In Carolina minds, "states' rights" had annulled the marriage.

North Carolina would join the Confederacy, and although there were strong, cautious voices questioning the alliance with the new Southern government, legislators chose to side with their slave-dominated Southern neighbors, who happened to surround them on all sides. In view of the circumstances, Carolinians felt somewhat resigned to accepting secession but never developed a frenzied enthusiasm for the Confederate government.

Passionate Unionist Zebulon Vance, who would serve as on officer in the Confederate army and would become governor of Carolina during the war, described his conflicted thoughts in this way, "[I] was pleading for the Union with hand upraised when the news came of Fort Sumter and Lincoln's call for [North Carolina] troops [to serve the Union cause]. When my hand came down...it fell slowly and sadly by the side of a Secessionist."[9] Many North Carolinians would echo his sentiment.

The *Confederate States* puzzle never sold well in North Carolina.

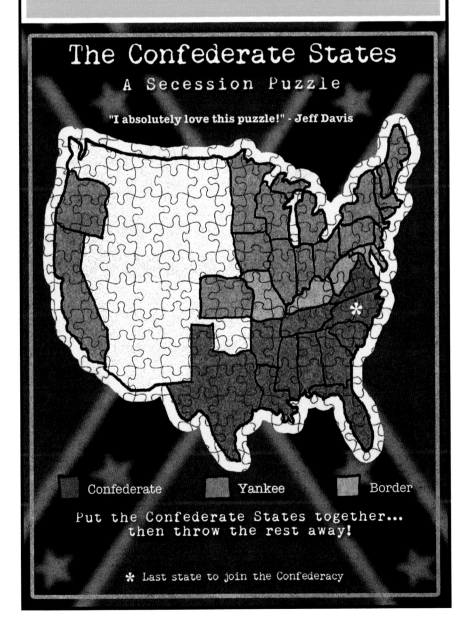

1861: The Civil War

Not unlike the Revolutionary War, North Carolina failed to experience a glut of immense, crucial battles during the Civil War, and most of its regiments shipped out for Confederate duty elsewhere. Granted, there were significant engagements along the coast—Roanoke, New Bern, Fort Macon, Fort Fisher, Plymouth—but all ultimately concluded in defeats, which gave the Union control of the Carolina coast.

Unlike the Revolutionary War, North Carolina provided more men for the Confederate cause than any other Southern state (over 125,000) and also led in the number of troops killed (over 40,000). Most of the battles were waged elsewhere and fought by Carolinians who had little vested interest in slavery—a compelling irony of the war. During the four-year conflict, thousands of slaves were also lost to Yankee armies, taking up arms and occasionally facing former owners in battle. The combined loss of black and white manpower would hobble the state for the next fifty years.

Early in the war, the Confederate Congress passed the Conscription Act, requiring enrollment of all males ages eighteen to thirty-five. Many Carolina men openly defied the Confederacy, bitterly resenting their interference in personal affairs. This would lead to an ugly internal brawl that would fester for the remainder of the war. Draft dodgers and pro-Union **bushwhackers** would harass Southern supply lines, loot homes and instill general discord, weakening the Confederate Home Guard tasked with rounding up men for the war. The Home Guard often retaliated indiscriminately.

One famously notorious event involved retribution against bushwhackers who had looted the town of Marshall, in western North Carolina. Hoping to catch the perpetrators, a group of Confederates surrounded Shelton Laurel, a nearby pro-Union community. Finding the culprits had escaped, the Confederates tortured and hanged several old women, then rode off toward Tennessee with a handful of young boys and old men as prisoners. Along the way, two prisoners escaped, and the commanding officer decided to dispatch the remaining innocents, murdering them execution style. Even impassioned Confederates were horrified at these developments.

For the majority of the war, Carolina Confederates were fighting elsewhere or wrestling home-grown bands of Union supporters—conditions that were almost identical for Patriot soldiers during the American Revolution. One final engagement, pitting twenty-two thousand Confederates against sixty thousand Union soldiers, would bring the war to a close on North Carolina soil.

Choosing sides was difficult.

1865: BATTLE OF BENTONVILLE

As the war rolled into its fourth miserable year, the Union army duplicated an effective British strategy from the Revolutionary War, minus the one small hiccup at the end (losing the war). In 1780, Cornwallis had conquered Georgia and South Carolina, then moved north to attack North Carolina. William Tecumseh Sherman would mirror his efforts, with a dissimilar enemy surrender capping his campaign.

After successfully squashing Savannah and Columbia, Sherman moved toward Goldsboro, hoping to destroy military targets—and anything else that would burn—along the way. Unlike Nathanael Greene, who led Cornwallis on a wild, exhausting ride through the woods, Confederate general Joseph E. Johnston decided to square off with a much stronger Union force. Ordered by General Lee to push Sherman back, Johnston attacked one wing of Sherman's troops on March 19 as it approached the town of Bentonville, about twenty miles west of Goldsboro. The heaviest fighting occurred on the first day, with significant causalities on both sides but no clear victor. Both armies fought valiantly into the wee hours of the night and remained entrenched after the first day. The second day of battle dissipated into a few small skirmishes and the removal of wounded from the field, while Sherman sent in another wing of his troops as reinforcement.

Facing an army almost triple his number, Johnston hoped Sherman would attack his well-entrenched front line on the third day. Instead, against Sherman's orders, one of his officers sent two brigades (about 2,400 men) against the Confederate left flank, almost overtaking the main Confederate force. After heavy fighting, Sherman called the attack off, and the Union forces retreated to their original lines. By the morning of the fourth day, the Confederates had slipped away under cover of night, and Sherman was content to let them escape. The Confederates had suffered over 2,600 casualties, and the Union's totaled 1,527. It was the bloodiest battle fought on North Carolina soil, and the defeat would precipitate the end of the war.

Two weeks after Bentonville, trapped in Virginia, Robert E. Lee surrendered his troops to Ulysses S. Grant, and Johnston would soon follow suit with his surrender to Sherman at the Bennett Farm near Durham. Johnston's surrender would disband all Confederate forces in North and South Carolina, Georgia and Florida—the largest group to surrender during the entire war.

After a rare Chinese dinner in Bentonville, Johnston decides to heed the fortune cookie.

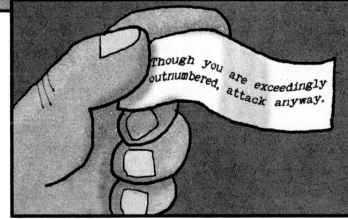

1865: THE TAR HEEL STATE

Conceivably wrought while crowded around a campfire, eating beans and telling war stories, some Confederate yahoo leaned forward and called a young soldier a "dang Tar Heel," not knowing exactly what it meant but proud of the association he had made between the Carolina boys and their grand naval stores. Initially fabricated as a derogatory nickname, the title enjoyed a few laughs but eventually came to be appreciated as a badge of honor.

The origin of the name Tar Heel has received expansive, ambiguous attention, but the above story is as good as any. There seems to be no doubt that the name draws relevance from the tar and pitch produced by the Old North State, which apparently could be seen on the bottom of any shoe that went near a naval store production facility. The name was popularized during the Civil War years, and North Carolinians came to appreciate and proudly own the title.

Today, the University of North Carolina at Chapel Hill claims the name Tar Heels for all its athletic teams while sporting a ram as its mascot (perhaps a big shoe with a black spot on it might have been more appropriate). Seeing that rams are not indigenous to North Carolina, one might be as curious as an Alabama fan wondering why the Crimson Tide has an elephant mascot. Apparently, according to school legend, there was a former football player by the name of Jack "the Battering Ram" Merit. Several years after he played, a team trainer had the bright idea of bringing a ram onto the field for good luck—sort of honoring Mr. Merit in a superstitious sports ritual sort of way. That day, the field goal kicker rubbed the ram's head before kicking the game-winning field goal, and intuitively, the university elected the ram as the new mascot! Unfortunately, the story doesn't end there. Today, the ram also sports a sailor's cap, representing the navy flight training program that was attached to the university during World War II (apparently, a novel way of supporting the troops).

Of course, all this ram/sailor cap stuff has nothing to do with Tar Heels or the Civil War, but it is ridiculously interesting history. In case anyone hopes to make a more logical case for the UNC ram mascot, North Carolina does possess an endangered mollusk called the Greenfield Ram's Horn.

1865: AFTERMATH OF THE CIVIL WAR

To put it succinctly, beyond the eradication of slavery, the Civil War was ONE GREAT BIG DISASTER for all of North Carolina, leaving the state defeated, impoverished, depleted of manpower and spiraling backward, out of control. The railroads were in desperate need of repair, educational institutions struggled to get back on their feet, families and their crops were ravaged, industry was in ruins and politicians faced a larger-than-life quandary, struggling to raise funds and then feuding over what to do with them. The new citizens, free blacks, would become a century-long conundrum; lawmakers would create policies and establish organizations to advance assimilation of former slaves while simultaneously trying to keep African Americans socially inferior.

Futuristically speaking, and far removed from the realities of a war-torn homeland, later Carolinians would look with pride (as did all other Southern states) on their stouthearted efforts during the "War of Northern Aggression." This was, of course, to be expected. It had been a long, hard war, and Carolina had sacrificed much for the Confederacy.

As early as 1901, an inspiring epitaph was sewn into the Tar Heel Civil War ethos: "First at Bethel, Farthest to the Front at Gettysburg and Last at Appomattox." This first-to-last catchphrase—dispersed by the Daughters of the Confederacy and other proud Confederate ancestors—spoke to the role North Carolina had played in the great conflict. "First at Bethel" referred to the first Confederate victory at the Battle of Big Bethel and the first soldier to die in the conflict; the First Regiment of North Carolina was instrumental in the victory, and, according to someone with a keen eye for death, the first Confederate to die in action was a Carolina boy. "Farthest to the Front" called attention to the North Carolina infantrymen who advanced the greatest distance against smothering gunfire at Gettysburg (someone must have had a tape measure). Finally, "Last at Appomattox" alluded to the Tar Heels who supposedly fired the last shots at Federal forces before the surrender at Appomattox.

All this to say that North Carolinians, as best they could, put a positive spin on their statewide disaster. To this day, the catchy expression is plastered on monuments, placards, T-shirts and websites across the state…reminding us that the Civil War was an acutely bleak time for the Tar Heels and optimistic slants were welcome.

1865: ANDREW JOHNSON

After Lincoln's assassination, Andrew Johnson, a native Carolinian, would become the state's third national president. As Lincoln's vice president, Johnson had been on John Wilkes Booth's hit list, but a nervous accomplice had failed to carry out the murder. Johnson would live to fulfill a four-year term, failing to become the first impeached president by a mere one vote (Congress claimed he had overstepped his executive powers). He lost his bid for a second presidency to General Grant, would serve again as a US senator in 1875 and died from a stroke after the first five months of his term.

Like the previous two presidents born in NC, Johnson spent his teenage years in the rural backcountry and eventually moved to Tennessee (apparently, if you were to become president in the 1800s, being born in NC and moving to Tennessee afforded you a good shot at the position). Johnson settled in Greenville and opened a successful tailoring business at the age of eighteen. He soon became involved in politics and moved quickly up the diplomatic ladder—town alderman, mayor, Tennessee House of Representatives and Senate—eventually attaining a position in the US Congress.

Johnson was voted governor of Tennessee in 1853, and by the time Lincoln was elected for his first term, he was a staunch Unionist senator who voted against Tennessee secession. Johnson left Tennessee when it joined the Confederacy (leaving his wife and children behind), but Lincoln soon appointed him military governor of Union-controlled portions of Tennessee (the Confederacy would respond by confiscating his land and turning his home into a military hospital).

In 1864, Lincoln, hoping to bolster Southern sympathies, supported Johnson as his Southern Democrat running mate. With his reelection, five days after Lee's surrender at Appomattox, Lincoln and Johnson began to strategize about the reconstruction of the South. Lincoln's murder would leave the arduous task to Johnson, who would become known for his racist approach to rebuilding the Southern states—as a former slave owner, he encouraged white supremacy as the modus operandi for restoring order. His mindset would trouble North Carolina, and the nation, for years to come.

Today, completing the presidential triad, a statue of Andrew Johnson sits by the head of Andrew Jackson's horse at the state capital in Raleigh…his plaque stating flatly, and unenthusiastically, "He defended the Constitution."

Harold Meyerowitz, undercover interpretive artist and former history major, strikes again.

1866: The Lowry War

As the Civil War drew to a close, a small county south of Fayetteville was just beginning to warm up to the idea of another war.

Robeson County happened to contain a large number of Lumbee Indians, noted at the time as "free people of color." Along with conscripting young men during the Civil War, the North Carolina Home Guard had developed the unwelcome habit of rounding up Native Americans to assist with the construction of Confederate forts. In response, a few Lumbee men had found refuge in local swamps, where Confederate soldiers were disinclined to visit. Relying on family and friends to survive, the Swamp Lumbee, as we might call them, found life more and more difficult as the ravages of war left their communities destitute. Some Lumbees, in particular the Lowry family, had grown weary of swamp life and had begun taking steps to improve their condition.

Stealing hogs, clothes and munitions from wealthy locals—and occasionally murdering them—the Lowry family not only stole what they needed but also gave some away to the poor. As Robin Hood discovered centuries earlier, word eventually got out. One unlucky day, the Home Guard showed up at the Lowrys' cabin, discovered a few items that didn't seem to belong and promptly executed the perpetrators—the family patriarch and one of his sons. Watching from a nearby thicket, Henry Lowry would soon start a vengeful seven-year war against the losing Confederate government and its wealthy white supporters.

In what was known as the Lowry War, Henry led a gang of relatives and friends on a series of rampages resulting in the murder of those he held responsible for his father's and brothers' deaths. Using the swamp as his headquarters, Lowry also opposed the Reconstruction efforts of President Johnson (the analogous sheriff of Nottingham) and his white-supremacist backers, robbing scores of Robeson County elites and eventually eliciting from the governor of North Carolina a $12,000 reward for his capture. Despite numerous efforts by authorities, the Lowry gang remained active and at large until 1872, when Henry suddenly disappeared from the scene, never to be seen again.

His war, and associated gifts to the poor, won the support of the local Lumbee tribe, who today consider him a hero in the fight for Indian rights (see "First Native American College" for more info on the Lumbee tribe).

1868: RECONSTRUCTION

Not long after the surrender of the Confederate States, the Fourteenth Amendment—granting, among other things, full US citizenship to former slaves—was passed by Congress. Barred from participating in the vote, Southern states were encouraged to amend their state constitutions to include this new "equalizer." In the meantime, with the Reconstruction Acts in force, all former Confederate states were under military control, incorporating Federal-sponsored leaders, Federal rebuilding programs and the humiliating presence of military troops.

When the NC State Convention reconvened in 1868, it was tasked with rewriting the state constitution, requiring the passage of the Fourteenth Amendment, the abolishment of slavery, and the nullification of any notions of secession. Free blacks now possessed a vote, and black delegates had been elected to the convention. All Confederate officers were prevented from participating. Union supporters (fondly referred to as **scalawags**) voted en mass. White northerners (**carpetbaggers**) had moved in to assist the effort. The new Republican-dominated convention ratified the constitution, and on July 4, 1868, to the dismay of Confederate democrats, NC rejoined the Union.

Like any decent Southern state, NC didn't really comply with the terms of Reconstruction. Once admitted back into the Union, legislators quickly took steps to undo changes that had been pushed on them by the "evil Yankees." A Republican governor (Holden) had been appointed for the state, but he was soon met with impeachment (the first governor in the United States to ever be impeached). Democrats regained control of the legislature, and before you could say, "**Jim Crow**," new laws were bringing back the good ol' white-dominated, rich landowner culture. Simultaneously, secret societies like the Ku Klux Klan began to form and terrorize blacks.

It would take ninety more years of activism and hard-won civil rights battles before NC would address its political heritage. In the meantime, reconstruction of the South slogged forward.

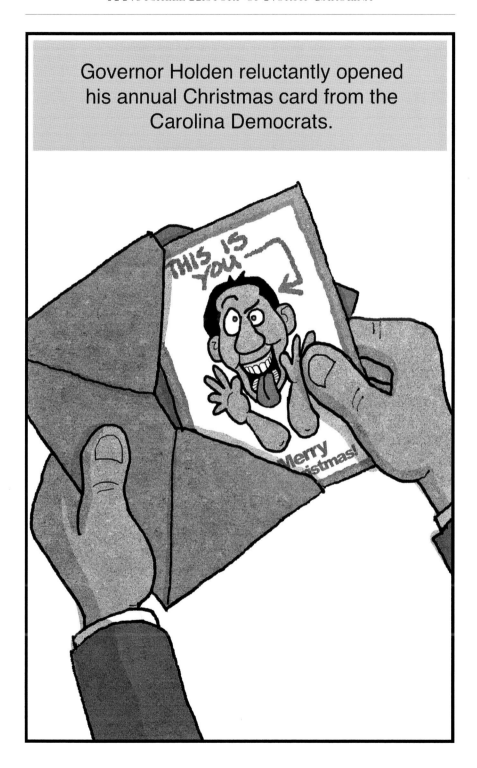

1878: CHEROKEE RESERVATION

The Cherokee, like the African Americans, were also welcomed back into the Union and in similarly awkward fashion.

Initially siding with the Confederacy in the War Between the States, the Cherokee Nation (which had been moved to the Oklahoma Territory) soon split over its allegiance. The Cherokee fought valiantly in a number of Union and Confederate victories, but like their white adversaries, they often fought against their own Cherokee neighbors. At the end of the war, in perhaps fitting manner, the Cherokee serving in the Oklahoma Territory were the last Confederate troops to surrender to the Federal government, in June 1865.

New treaties written after the war parceled out Cherokee land to railroads and white settlers, and to hurry assimilation along, the Cherokee were encouraged to purchase private property and disperse. By 1898, the US government no longer recognized tribal governments in Oklahoma. President Roosevelt would reverse this policy in 1934 with the Indian Reorganization Act, allowing Native Americans to preserve and restore their traditions and culture. Today, the Cherokee in Oklahoma occupy fourteen counties of privately owned, non-reservation land. Considered the Cherokee Nation of Oklahoma, they are a sovereign nation, providing their own system of governance.

The Eastern Band of Cherokee (located in NC) fought exclusively for the Confederacy during the Civil War, and in recognition of their service, NC acknowledged the legal right of the Cherokee to live on Carolina soil (very generous indeed!). Under the new NC state constitution, the Cherokee were encompassed by the warm embrace of the Fourteenth Amendment but were also shackled, so to speak, in a uniquely bizarre kinship to the black community. Despite their heroics in the war (and their ownership of black slaves), the Cherokee would be considered "colored people" by NC and were soon subject to the same racially discriminatory laws forced on the "other" colored people. Blacks and Native Americans in NC would not experience their true constitutional rights until the civil rights movement of the 1960s.

In 1868, Congress recognized the Eastern Band of the Cherokee as a separate tribe from their brothers in Oklahoma, and by 1878, NC considered the Qualla Boundary an official **Cherokee Reservation**. Today, the reservation is located on 82.6 square miles of western NC, a slight reduction of acreage that once included large chunks of NC, SC, GA, AL, TN and KY.

From a distance, tourists often mistook the message of the giant Cherokee.

1890: COTTON, RICE AND TOBACCO

Enough of the Civil War and other well-mannered conflicts—for North Carolina, the time had come to get back to the nitty-gritty business of building a stable economy. Pauperized by the Civil War, North Carolina sought to rebuild itself on its former agricultural triumphs: cotton, rice and tobacco.

By the end of the nineteenth century, cotton was almost king. Metropolitan areas remained sparse in the east, but the Piedmont begin to bulge—and cotton mills proliferated to handle the growing demands for cloth. With the loss of slave labor, mechanization provided low-wage factory jobs that allowed cotton manufacturers to remain profitable (be assured, profitable little children were also put to work). By 1890, North Carolina boasted 177 cotton mills, utilizing over thirty thousand workers to produce $28.4 million worth of products—thousands of yards of cloth for underwear, socks, shirts, trousers, dresses, hats, jackets and Confederate flags (for memorabilia purposes, of course). All this industrious cotton production came woefully short of producing moderate incomes—North Carolina cotton mill workers remained unpretentiously poor—but factory towns bustled with activity, and that was worth "something" to the floundering state.

The formerly successful rice plantations on the east coast proved less fortunate. Though they had prospered in North Carolina for almost two hundred years, with the end of slavery (and "free" labor), the large rice plantations began to shrivel up. Freedmen (free slaves) and former rice farmers continued to produce the crop on a smaller scale, but profit margins plunged and so did rice farming. Toward the end of the nineteenth century, several developments in rice production technology looked promising, but a series of nasty tropical storms would dash all ambitions; in the 1890s alone, over twenty tropical storms battered the coastline. In 1899, Hurricane San Ciriaco, the first named hurricane of North Carolina, hit Hatteras at a crushing, plantation-smashing 120 miles per hour. It wasn't the beginning of the end for North Carolina rice. It was *the end*. And so concluded the largest African contribution to North Carolina agriculture.

Meanwhile, North Carolina's health-prohibitive crop was topping the charts for sales, marketing efforts and addictive behaviors. By 1890, tobacco was on its way to becoming the number one agricultural product of the next century—deserving its own full-page narrative.

Hunting for a job, Bob stopped
at the sign post. After pondering a moment, he
suddenly felt a sense of direction.

1893: THE TOBACCO STATE

Serving against his will, thirty-three-year-old George Washington Duke fought with the Confederate navy for two years. In the boring lull between engagements, Duke noticed the rampant use of tobacco—to soothe the impending doom, soldiers consumed large quantities by chewing or smoking it. Duke also astutely observed that much of the South's valuable tobacco industry had been uprooted by the Civil War. Crops had been destroyed, agricultural habits interrupted and Confederate laws had been passed to limit the growth of tobacco, encouraging farmers to grow much-needed foodstuffs instead.

When Duke exited his short military career, the war had afforded the opportunity to establish a tobacco empire, and he wasted no time in building it. Utilizing the popular NC-bred bright-leaf tobacco, Duke began growing and marketing his addictive product. Moving to Durham in 1874, Duke hired workers to process tobacco for pipe smokers or cigarette smokers who rolled their own. Duke's two sons became involved in the operation of the factory, and Washington (as he was fondly known) focused his genius on marketing.

In 1881, to one-up the tobacco competition, Duke began manufacturing hand-rolled cigarettes. Although his workers could crank out 4 cigarettes per minute, the process was tedious and, frankly, rather unfulfilling for ten consecutive hours. To remedy the situation and, more likely, to meet the growing demand for cigarettes, in 1884 Duke purchased a newly invented Bonsack automated hand-roller. Although a bit finicky, when functioning properly the machine could deftly roll 144 cigarettes per minute. Thereafter, and without fanfare, the new cigarette industry would charge butt-first into the trash receptacles, sidewalks and roadsides of American history.

In 1890, the wealthy Duke brothers (who had inherited the business) would propose a successful merger with their remaining competitors, creating the American Tobacco Company, forming the largest and most lucrative tobacco company in the world. By 1893, NC had become the epicenter of the tobacco industry and remains so today, producing over twice as much tobacco as any other state. Along with producing the largest cash crop the state would ever know, providing thousands of jobs and funding the elite Duke University, the Duke family would unintentionally mass produce the deadliest weapon in modern history. The esteemed and magnificently advertised cigarette would kill over 100 million people in the twentieth century.

1895: THE BILTMORE HOUSE

Meanwhile, Cornelius Vanderbilt had commenced another, less life-threatening venture north of Durham. Monopolizing the shipping and railroad industries of New York State and beyond, Vanderbilt had amassed unprecedented fortunes. Upon his death (many were glad he took nothing with him), Cornelius left a crisp $169 million with his son Billy. Billy lived another nine years and inflated the family fortune to a generous $231 million. Upon his unfortunate passing, his eight children, the youngest being George, received a decent stipend.

A lover of books, great architecture, fine art and science projects, George Vanderbilt opted to use his stipend (roughly $12 million) to build a palatial mansion in the mountains of western NC—an area he had visited during summer vacations with his mum. Captivated with Asheville's cool climate and scenic vistas, George envisioned a self-sustaining estate that would showcase his books, exotic art collection and a multitude of income-generating scientific endeavors: forestry programs; horse, hog, poultry and cattle farms; and a dairy.

Calling his estate Biltmore, in reference to his Dutch ancestry and the rolling hills of the estate, George purchased a colossal 125,000 acres and proceeded to construct his epic vacation destination, creating the largest, most opulent private home in America. George also developed immaculate flower gardens, tenant farms and a quaint shopping village, which included a school and church for his employees. By hiring experts in every imaginable endeavor, Vanderbilt soon created a bona fide empire, employing hundreds of local workers led by like-minded visionaries. His passion for learning, his vision for conservation and his diminishing bank account led to the establishment of Pisgah National Forest, a blossoming arts and crafts industry, a booming tourist destination and the first school of forestry in America. No small feat for a quiet bookworm.

Having opened his French-inspired estate to friends on Christmas Eve 1895, George would enjoy his immense experiment for the next nineteen years—but the upkeep of his dream would prove fatal to his inheritance. By the time of his death in 1914, his wife would sell portions of land and Biltmore industry to keep the handsome, struggling estate afloat. Opened to the public as a museum and pleasuring ground in 1930, the remaining eight-thousand-acre Biltmore Estate would commemorate an inspiring and audacious experiment in gaudy country living and self-sustaining agriculture.

1898: THE CRADLE OF FORESTRY

George Vanderbilt's love of books played a pivotal role in the formation of America's first school of forestry. It would also involve German intervention.

During his extravagant lifetime, George Vanderbilt developed an insatiable appetite for books. Beginning at the age of twelve, he read an average of 81 books a year for the remainder of his life. Delivered from the curse of Steve Jobs (iPhones, streaming movies and video games), George managed to wrap his mind around some relatively heavy subjects—renaissance art, classical literature, architecture, animal science, botany, astronomy and agriculture—all easily accessible from his library of 22,784 books. Books informed all his grand schemes.

A scholar savvy enough to surround himself with first-class mentors—and eccentric enough to avoid looking at his bank account—Vanderbilt hired the renowned forester Gifford Pinchot to manage his vast forests. Pinchot strategically developed a plan of "forest management," a progressive concept that proposed a scientific program of harvesting and replanting (Pinchot was averse to the idea of forest preservation). Leaving Biltmore to assume the directorship of the US Forest Service, which quickly adopted Pinchot's fondness for cutting down trees and building dams, Pinchot recommended a German replacement by the name of Carl Schenck. It would prove to be a fortuitous upgrade.

Having recently completed his PhD in forestry, Schenck accepted Vanderbilt's offer, arriving from Germany in 1895. Carl employed forestry techniques never seen in the United States—developing tree nurseries and seed extraction methods, establishing fish hatcheries and making other habitat improvements that would bolster production and protect forest resources and watersheds. Unlike Pinchot, Schenck was an educator and conservationist, eager to share his stewardship model with local farmers and lumbermen.

Pursuing his passion, in 1898 Schenck received Vanderbilt's permission to open the Biltmore Forest School, the first school for the scientific study of forestry in the United States. Meeting in an abandoned farmhouse, the school provided a one-year curriculum that combined classroom silvicultural theory with hands-on field training—a model that would produce America's leading foresters in the early twentieth century. The Biltmore Forest School would operate for eleven years on 6,500 acres of Vanderbilt's land (now part of Pisgah National Forest), would graduate 350 students and would eventually be designated by Congress as "the Cradle of Forestry" in America, a National Historic Site commemorating NC's contribution to forest conservation.

1898: The Wilmington Insurrection

While Michael Jordan's jersey wafts majestically from the ceiling of the Dean Dome, the University of North Carolina hides a copy of Alfred Waddell's diploma in a damp, smelly basement of the registrar's building, tucked away in a rusted-out file cabinet labeled "Ignoble Graduates." It is there for good reason.

Waddell led the only coup d'état in American history—a coup worth forgetting. Graduating from UNC in 1853, Waddell fought for the Confederacy and became a staunch white supremacist, whom a Democratic NC elected to three terms in the US Congress. Working as a lawyer in Wilmington, Waddell faced off against his Republican rival, Daniel Russell. Both served among a large number of black craftsmen, policemen, bankers, merchants and clergymen. In 1896, Russell became the first Republican governor to be elected after the Reconstruction period, and he quickly moved to give NC blacks more voting power.

In the following 1898 Wilmington elections, Waddell offered a strategy to deter the black vote and ensure a Democratic victory: "Go to the polls tomorrow, and if you find the negro out voting, tell him to leave the polls and if he refuses, kill him, shoot him down in his tracks."[10] Undeterred, a large turnout of black voters elected a Republican-backed biracial government, featuring a white mayor and a council consisting of one-third blacks. Waddell and his **Red Shirt** thugs were not pleased. Delivering an ultimatum for officials to vacate their positions, Waddell organized a small army of men and proceeded to destroy the buildings of the *Daily Record*, Wilmington's black newspaper. With violence escalating, government officials fled, and the small army quickly degenerated into a vengeful mob of over two thousand. Black businesses and neighborhoods were attacked, over twenty-five blacks were murdered (numbers were most likely higher) and hundreds left Wilmington, fearing for their lives. Governor Russell called for assistance from his own Wilmington Infantry, but it deployed and moved to the aid of the white attackers instead.

After the "Wilmington Insurrection" subsided, Waddell appointed a new council and had himself elected mayor of Wilmington. Incredulously, no one stopped him, no one indicted the mob for murder and no one prevented the violent takeover of NC's largest city. Waddell served as mayor of Wilmington for seven years and would effectively prevent blacks from serving in politics for the next sixty years.

A copy of "My Supreme Diary," Waddell's daily musings, was recently discovered in a Wilmington dumpster, located next to city hall.

april 17 –

1901
continued

Because my skin has has very little pigment, it must be concluded that I am a great man.

april 18 –
Today, I considered running for President.

april 19 –
I almost disowned my own daughter today. But then I discovered that it was just a "sun tan". Whew... that was a scary moment for me!

april 20 –
Tommorow I will outline my plan to ban the use of black crayons in public schools.

1903: The Flying Brothers

Meanwhile, a few miles north of Wilmington—away from the hubbub of political coups and murder—two bicycle shop owners were on the verge of changing how the world traveled.

Born in the Midwest three years apart, dedicated bachelors and self-taught engineers, the Wright brothers failed to graduate from high school, developed a small printing business and finally opened a bicycle shop together in the town of Dayton, Ohio. Hoping to cash-in on the new bicycle craze, Wilbur and Orville Wright, twenty-five and twenty-two, respectively, spent their time selling and repairing bicycles while deliberating the ongoing international race for manned flight. Disinclined to dawdle away their spare time, the brothers soon took an active interest in their growing passion: aeronautics. At some point in their captivating bike shop discussions, these two idealistic, nongovernment-sponsored, unknown and uneducated bike mechanics came to an unlikely conclusion: "We can outsmart the global scientific community by building the first manned, power-driven, heavier-than-air machine that can sustain a free and controlled flight." Looking back at their audacity, the good people of Dayton conceivably could have referred to the geeky bike shop owners as "the Nut Brothers."

Undaunted by their own naïvety, Wilbur and Orville would spend eight years preparing their manned glider for flight. With a brilliant concoction of cambered wings, wing-warping capabilities and lightweight construction, the Wrights would combine current aeronautical knowledge with one major improvement: **three-axis control**. Until their historic flight, no potential aviator had understood how to mechanically navigate a flying machine, but after years of exhaustive research, the Wrights had figured it out.

Taking their ideas to Kitty Hawk, North Carolina (Kill Devil Hills is now considered the accurate location), the brothers conducted three years of extensive testing on their flyer on the windy shores of the Outer Banks. Returning each year with a better design, in 1903 the brothers arrived with the addition of a custom-made engine, two propellers and a small crew to witness history. On December 17, on the fourth and longest flight, Wilbur cleared 852 feet in fifty-nine seconds—the first to experience a controlled, airborne voyage.

While North Carolina claims ownership of the first controlled flight, Ohio declares ownership of the Wright brothers and their ideas. Confusing matters further, Connecticut claims its own Gustave Whitehead flew two years prior to the Wright Brothers, passing a law in 2014 to declare its supremacy.

1918: FORT BRAGG

The truth is, no matter what the NC license plate says, the Wright brothers were not "First in Flight." Many flying machines had taken to the air prior to their NC debut. Technically speaking, the brothers were first in "controlled flight," utilizing a complex system of cables and levers to maneuver their winged contraption. Today, pilots still use the same basic flying controls designed by Wilbur and Orville, an amazing achievement for the two uneducated engineers. Less amazing is the fact that within eleven years of their invention, humans had figured out how to employ their machine to kill one another more effectively. Orville would lament this fact years later.

By 1914, Europe was at war again, and military strategists had discovered the flying machine. Initially finding the airplane a boon for reconnaissance, pilots soon discovered that they could shoot pistols, throw hand grenades and toss bombs from the cockpit—what a thrill to kill from the air! But by the time the United States entered World War I, bombing technologies were still in their infancy, and airplanes found their most useful calling as artillery rangefinders, helping long-range artillery units refine their aim. For this unique calling, Camp Bragg was established north of Fayetteville, NC, in 1918.

Named for Braxton Bragg, a native Carolinian artillery officer and Confederate general, Camp Bragg became an artillery and aeronautics training ground for World War I enrollees. At the end of the war, the camp was scheduled for closure until the commanding officer convinced the army to transfer the entire Field Artillery Department to the site. Renamed Fort Bragg, to indicate its permanent status, the fort would grow to be *the* largest military installation in the world (which is why it's in this book). Today, the complex encompasses four counties, contains a population of over fifty thousand active-duty soldiers and covers 254 square miles. Fort Bragg houses the US Army and Army Reserve Command, Army Airborne Forces and the Special Forces Units (Green Berets, Rangers, Delta Force and Eighty-Second Airborne).

If you know someone in the US Army, there's a good chance they spent training time at Fort Bragg, home of the original flying rangefinder, unwittingly invented by the humble, non-warring bike shop owners from Ohio.

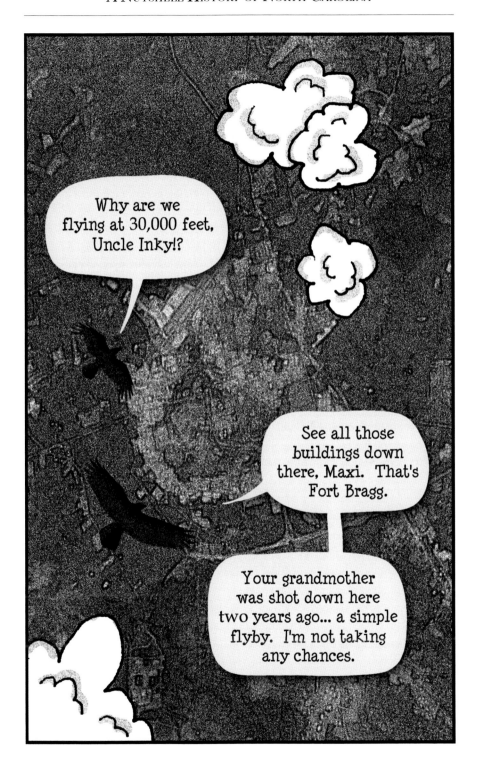

1923: Tourism Boom

By the end of World War I, NC had sent 86,457 conscripted soldiers to fight on European soil. New technologies, including the airplane, had changed the dynamics of warfare, accounting for unprecedented losses and unparalleled brutality. Despite its brief involvement in the war, NC yielded over 6,000 casualties and 4,000 deserters. Simultaneously, and unnervingly, the Blue Death (a unique strain of the flu) took 13,000 North Carolinians on the homefront.

Unexpectedly, the demands of war improved a number of local NC economies: Wilmington shipyards rumbled with activity, furniture makers in High Point fabricated scores of propellers, Raleigh produced millions of artillery shells, Durham rolled out boatloads of cigarettes, and cotton mills, of which there were many, wove yards of blankets, tents and socks for the war effort. All this exertion produced sizable profits, enriching the pockets of the wealthy and trickling down some extra cash for laborers. Of course, most of this applied only to the urban population. Approximately 75 percent of Carolinians still lived in agricultural territory—a dominion occupied by struggling farmers who found small-time agricultural pursuits less and less profitable.

The end of the war also brought new connections to NC, as cars and telephones, radios and music, national reforms and educational movements swept the country, chipping away at the isolationist theology of the Tar Heel State. From this melting pot of warring industry, expanding wallets, catastrophic disease, floundering farms and social/technological advancements, NC emerged, astonishingly, as an esteemed place to relax and have fun.

The Roaring Twenties, as they were rapturously christened, were not so roaring in NC, but the uncluttered coastline and the cool mountain air offered travelers an alluring place of respite. As money and leisure pursuits increased nationally, NC retreats popped up en mass. With the **Good Roads Movement** in full swing, a marketing machine in place (newspapers) and a swelling travel bug, NC was on the cusp of becoming prime tourist territory. Asheville, and its surrounding mountain beauty, was billed as the hiking, camping, golfing Land of the Sky, and the Outer Banks boasted historic pristine beaches, prime real estate and top-notch game fishing. Everything in between offered agreeable weather, barbecue, a retreat center and a local craft shop. The boom was on.

Today, North Carolina's tourism industry contributes over $19 billion each year to its economy, provides $5 billion to the state's coffers and employs over 200,000 people.

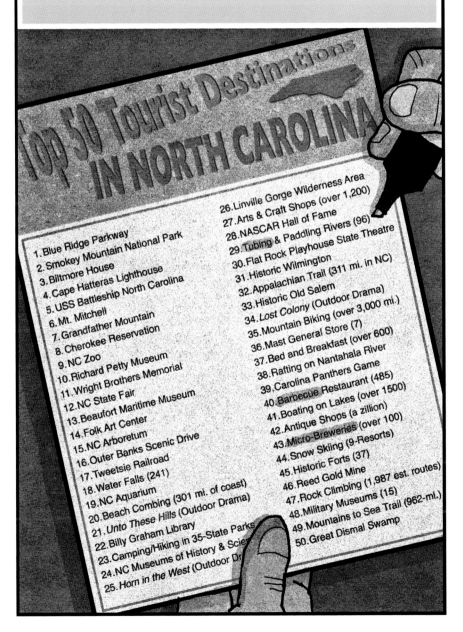

1925: The Highway System

Given NC's historical "Rip Van Winkle" avoidance of public improvements—that is, neglecting roads, bridges and other public works—you may be shocked to learn that as of the twenty-first century, NC had developed the largest system of state-maintained highways in the United States. Currently, the state manages over 77,400 miles of roads and bridges, and give or take a few hundred miles (and I-26 south of Asheville), they're all in reasonably good shape!

Of course, if you've been paying attention, you're asking, "How in the name of Frankland did this about-face happen?" This interesting story is conveyed forthwith.

In 1915, one writer described the budding era of the automobile in this way: "Men no longer buy cars for the fun of discovering why they won't [run], but wholly in the [routine] expectation that they will." This unprecedented shift in auto reliability changed the face of transportation, and soon enough, men, women, cousins and in-laws were driving themselves silly. In the early stages of auto obsession, NC roads were in deplorable condition. While a few cities boasted hard top, a majority of rural NC—where roads were funded by fickle county budgets—enjoyed mud holes, dust, rotted bridges and footpaths doubling as roads. The Good Roads Movement (GRM) began to change all this.

Initiated by bicyclists clamoring for better country roads, the GRM mutated into a national movement for road building in rural areas. While the GRM created political impetus for building modern roads ("Vote for me and I'll improve your roads"), another homegrown movement, spawned by the GRM, began to transform the Tar Heel State. The NC Good Roads Association, founded in Raleigh, began pushing state legislators to build and maintain a system of roads supported by license fees and gasoline taxes (a scandalous and rare instance of NC citizens imploring government to tax them). In 1921, when the federal government offered road-building funds to states that would match the contribution, the NC General Assembly responded by creating a state highway system and funding it with a $50 million road-building bond (taxes would follow). NC was on its way to modernization.

By 1925, NC could claim over 7,500 miles of hard-topped, gas-guzzling travel. And by 2015, an extravagant system of roads had made the state accessible to tourists, commerce and industry.

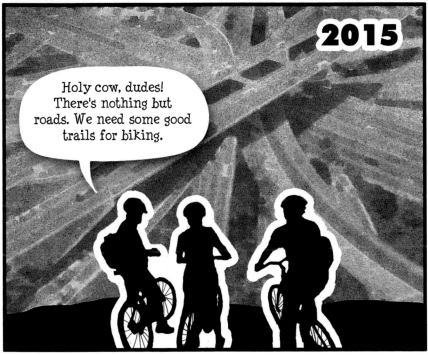

1930: FAST MOONSHINE

With the advent of reliable travel and the dawn of Prohibition, two new industries began to blossom in NC: auto racing and moonshine, otherwise known as fast cars and hard liquor. Although racing was a relatively new development, homebrew had been a colonial pastime for over two hundred years, allowing local distillers to get drunk without leaving the house—and creating the opportunity for immediate wealth among thirsty neighbors. Rather than limit the consumption of alcohol, the 1920s Prohibition initiative established a wildly successful black market—one in which many western Carolinians, who were already brewing white lightning, gladly enrolled.

The moonshine industry required a moonshiner (a producer), a runner (someone to transport the product in a vehicle) and a bootlegger (the seller)—all officially illegal. Although these tasks where often rolled into one, a well-organized moonshining team could be ridiculously profitable if they remained out of harm's way—that is, avoided revenuers (law enforcement). To increase their odds for success, runners began modifying their vehicles, not only to hide the moonshine, but also to outrun the law. And thus was born two symbiotic industries that would energize rural NC for the next fifty years.

Wilkes County, the self-proclaimed "Moonshine Capital of the World," would become host to a horde of drunk people and fast cars, serendipitously producing NC's first racetrack, running from Wilkesboro to Charlotte, where demand for moonshine was high. By the early 1930s, Prohibition had been repealed, and moonshine—still illegal—had become less appealing. Within a decade, auto racing had slowly crept into the white male consciousness as a way to legally drive fast and get paid for it. Racetracks began to pop up across the western part of the state, and by the 1940s, many former moonshine runners were suddenly in great demand as professional, respected drivers.

By the 1960s, stock car racing, as NC's special brand of racing came to be known, had stormed the state and gained a massive following. NASCAR (National Association of Stock Car Auto Racing) became the official sanctioning body, RJ Reynolds Tobacco Company became the official sponsor and the auto industry happily accommodated drivers with upgraded versions of its common "stock." Today, NC stock car racing is an annual billion-dollar business.

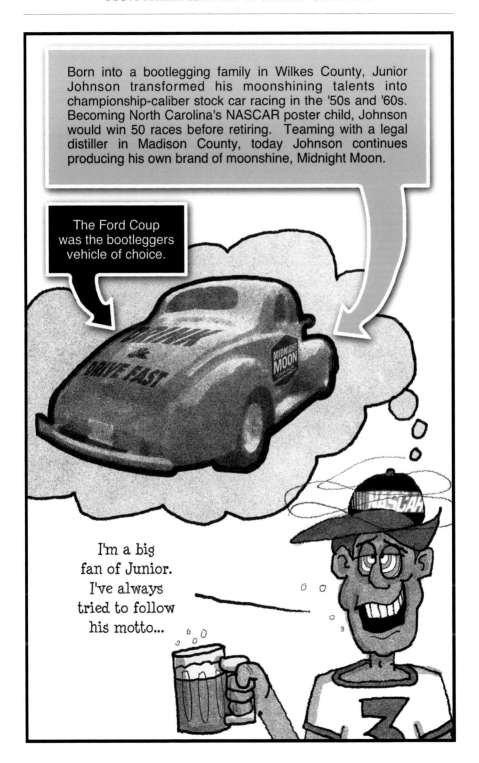

1930: THE FURNITURE INDUSTRY

Recalling the abundant greenery of colonial days (see "Naval Store Industry"), it should come as no surprise that trees would play an important role in the economy of NC. So large was their role that by the early 1900s, most of NC's virgin timber had been chopped down, de-branched, dragged down to a railroad and sent north for processing. George Vanderbilt, who had seen the rampant deforestation around Asheville, hoped his Biltmore Forest School would develop techniques to conserve what was left. Ernest Ansel Snow had different ideas.

Ernest was raised in a lumber family in High Point, NC, and helped his father sell timber to furniture companies in the North. After returning from one of his long trips to Baltimore, it occurred to Snow that it might be more efficient to "make this stuff at home." He quickly engaged a few business partners and was soon shipping furniture from his High Point Furniture Company. Within a few short years, Snow was building furniture for the Sears & Roebuck catalogue, establishing other factories (for pianos, chairs and wheels) and managing his hardwood forests for maximum output—that is, for deforestation.

Thanks to centralized railroad routes, an agricultural depression, cheap labor and a vast supply of lumber, other entrepreneurs promptly joined the rapidly growing furniture mecca of High Point, constructing thirteen furniture factories by 1900. As production soared, manufacturers began looking for better ways to showcase their furniture to dealers and buyers. The solution was simple: a big furniture party. In 1905, the first Southern Furniture Exposition (SFE) was held in High Point, eventually becoming a semiannual event that today attracts over eighty thousand buyers from one hundred countries.[*]

By 1930, Ernest Snow had converted High Point into the "Furniture Capital of the World"—an amazing feat for a small-town lumberman with an eye for efficiency. Though the Swedish (IKEA) and Chinese (Broyhill) have made substantial inroads into NC furniture production, in 2015 High Point still holds its own as *the* place to see and order the latest, greatest furniture.

[*]Imagine walking through a furniture store with ten million square feet while trying to find a nice coffee table for your rustic cabin. After reviewing thirty-six hundred coffee tables, you are overwhelmed. This is the essence of the SFE, now conveniently called the High Point Market.

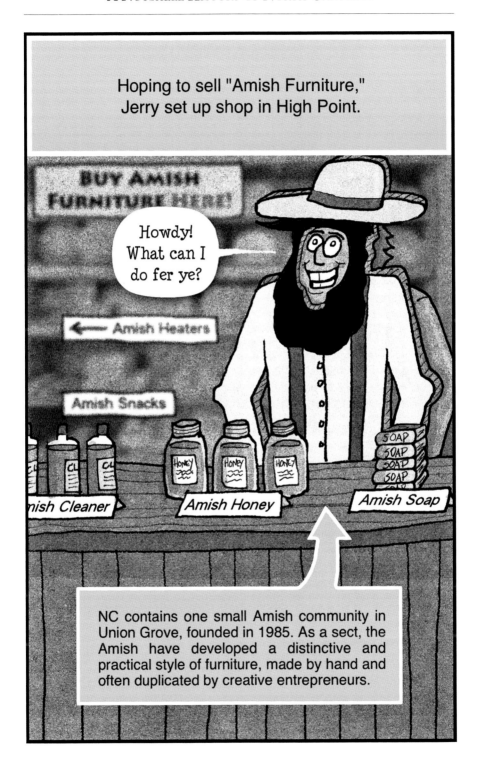

1935: THE BLUE RIDGE PARKWAY

From 1929 to 1939, the miserly grip of the Great Depression brought suffering and struggle to the entire nation. By 1933, half of America's banks had closed, consumer spending was at a standstill, faltering companies laid off workers and over thirteen million Americans were unemployed. The United States would not overcome its funk until 1939, when the next world war brought demands for new and improved killing machines—a sadistic economic twist that put the nation back to work.

In the midst of the Depression, President Roosevelt would install a series of domestic programs (New Deals) that would alter the face of government intervention forever (can you say social security, unemployment insurance and agricultural subsidies without getting mad?). One of these programs (the WPA)—designed to boost local economies by providing jobs—hired local workers to build a long list of public works projects, including schools, post offices, highways and parks. NC would enter the federal giveaway contest when an old idea resurfaced in congressional circles. In 1909, a Carolina geologist by the name of Joseph Pratt had proposed a scenic toll road connecting GA, NC, TN and VA. The visionary project, Crest of the Blue Ridge Highway, was designed to incorporate the best scenic views of the mountains and had the backing of all four states. Begun in 1912, the project was abandoned within two years due to financial shortages and engineering challenges. Twenty-one years later, with a large influx of federal cash, Pratt's project was back on the drawing board.

Lengthier and traversing a variety of historic and scenic sites, the newly named Appalachian Scenic Highway would travel from the Shenandoah Valley of VA to the Smoky Mountains of NC. Maddening to configure and specializing in outrageous political posturing, the route would eventually include 217 miles in VA and 252 miles in NC (GA and TN would lose out, while the city of Asheville maneuvered the route to its doorstep). Utilizing private contractors and local crews from the **Civilian Conservation Corps** (CCC), construction began in September 1935 and would continue for the next fifty-two years, costing over $8 billion in twenty-first-century cash.

The Blue Ridge Parkway, as it eventually came to be called (third name's a charm), would become the nation's longest National Park, with over twenty million annual visitors depositing carloads of cash in NC and VA.

1937: THE APPALACHIAN TRAIL

Evidently, the early 1900s was the age of lofty, idealistic, ridiculously expensive, Herculean projects. And to the amazement of today's millennials, the crazy workaholic visionaries who imagined these amusing schemes were able to pull them off—if not in their lifetimes, then in the lifetimes of their followers, in whom they had planted their extravagant dreams.

Along with the Wright brothers (controlled, sustained flight) and Joseph Pratt (Blue Ridge Parkway), Benton MacKaye of CT would fit snugly into this narrow realm of discerning romantics. Born into the home of a struggling actor, Benton would be raised in a hodgepodge of urban environments that would leave him bored and stressed. At the age of eight, Benton found his first flicker of inspiration in a short visit to the countryside—finding the beauty and freedom of nature a respite for his young soul. His regular return to the country, and its alluring peace, would direct the course of his life.

Benton would eventually teach forestry at Harvard, explore the relationship between land conservation and recreation, oppose urban sprawl and discover his life's purpose in the grand, romantic idea of the Appalachian Trail (AT). Originally proposed in a 1921 academic paper, MacKaye's vision was to form a system of preexisting trails, farms and campsites into one, long contiguous trail from ME to GA, accomplished by volunteers and nature-loving donors—by any standards, a monstrously exorbitant and impertinent idea.

A product of the 1920s hardworking, optimistic mindset, the AT concept was quickly adopted by hiking clubs, Boy Scout chapters, camping enthusiasts and even Roosevelt's CCC. As early as 1923, the first 45-mile section of the trail was open, and within sixteen years of the original proposal, the 2,200-mile Appalachian Trail was officially completed—an astounding accomplishment by any comparison. The AT would traverse GA, NC, TN, VA, WV, MD, PA, NJ, NY, CT, MA, VT, NH and ME, with the NC section running for about 200 miles.* Benton would form the Appalachian Trail Conservancy (ATC) to oversee trail development, and the trail would eventually be managed by the combined efforts of the ATC, National Park Service and US Forest Service. Today, the AT has seen over fifteen thousand **thru-hikers** and is considered the longest hiking-only trail in the world.

*NC's own Mountain-to-Sea Trail (from Clingmans Dome to Jockey Ridge State Park) is over half complete and plans to span the entire state, over nine hundred miles.

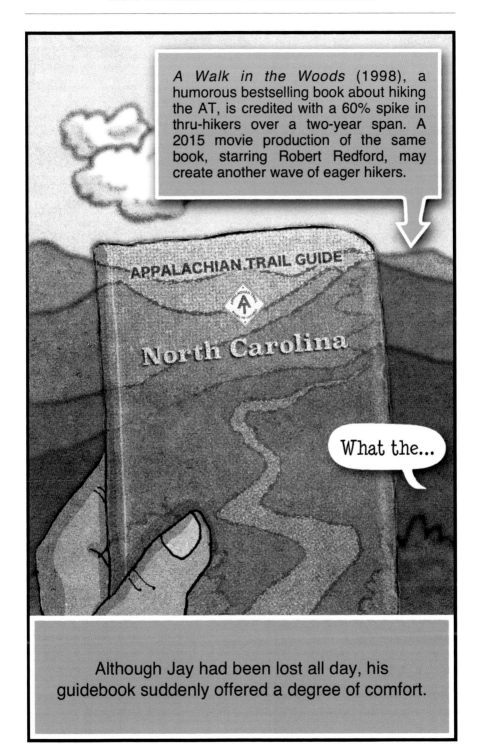

1940: GREAT SMOKY MOUNTAIN NATIONAL PARK

If you haven't noticed yet, a multitude of NC's natural resources had been sought out, used up or touristized by the early 1900s. Following a truly American equation—integrating a thoughtful combination of Manifest Destiny, violence, opportunism, resource depletion and tacky tourist shops—Carolinians had been simply "doing the math" that would be duplicated thousands of times across a diminishing western frontier.

This synergistic and disruptive social formula had been thoroughly understood by early conservationist John Muir, who attempted to circumvent the predictable results. His visionary efforts prompted the creation of California's Yosemite National Park and led to a general conservation ethic that made its way back east.

In a growing tide of preservation, Tar Heels and Volunteers (Tennesseans' dutiful nickname) found common ground in the indiscriminate logging, mining and homesteading of former Cherokee lands bordering their states. Hoping to establish an eastern version of Yosemite, politicians moved to create a National Park utilizing state funds, private donations and purchased lands. After a prolonged battle of wills, in 1940, the Great Smoky Mountains National Park became the first national park created on non-federal land. Over 1,200 homesteaders were bought out and removed, leaving behind the largest collection of abandoned farms, mills, schools, logging camps, mines and churches in the United States. By the time all the logging companies had been bought out, only 20 percent of the designated forests still remained untouched—but as the old adage goes, "better late than never."

The Smoky Mountains, named for the conifer-produced "blue smoke" that hovers over the valleys, would become the most-visited National Park in the United States. Today, it encompasses 816 square miles of forest and contains over 850 miles of hiking trails, mockingly adjacent to the old Qualla Boundary, where the remnant Eastern Band of Cherokees—who formerly owned the park territory (and then some)—now reside (in a sweet, mildly intoxicating revenge, the Qualla Boundary contains a gambling casino just a few miles south of the park entrance, gladly relieving Anglo-Saxons of their Manifest Destiny).

Great Smoky Mountain National Park includes a vast, protected, ecologically inspiring smorgasbord of flora and fauna (as well as the aforementioned artifacts of human habitat) and is designated as an **International Biosphere Reserve** by the United Nations. Ignoring the tourist meccas of Gatlinburg and Cherokee, which border the park's north and south boundaries, respectively, John Muir would have been mostly impressed.

1941: World War II

It should not go unnoticed that the grueling manual labor of the Civilian Conservation Corps added significant mileage to the Blue Ridge Parkway, trails of the AT and infrastructure of the Great Smoky Mountain National Park. But by 1941, North Carolina—and the nation—was still in a dismal economic slump, and Roosevelt's CCC was unable to alter the trend. Remarkably, and uncharacteristically, it would be the Japanese who finally developed a strategy for lifting America out of the doldrums.

Calling their plan "Let's Go to War," the Japanese attack on Pearl Harbor on December 7, 1941, left the nation gasping in shock—and eager for a means of returning the favor. The response sent 16.1 million American men into service and, almost overnight, resurrected a struggling economy. For its part, North Carolina would build ships and supply textile goods, lumber, tobacco and food. Over 362,500 North Carolina men and women served willingly as officers, technicians, infantry, pilots and seamen—and of those soldiers who fought overseas, more than 8,500 would not return home. During the war, North Carolina trained more troops than any other state, with Fort Bragg growing to a post of over 100,000. Unbeknownst to most Carolinians, over 10,000 enemy soldiers were detained in seventeen POW camps during the war, often housed in small communities and put to work as paid employees of farms, factories, lumber mills and road crews (years later, many POWs would fondly remember their days in North Carolina and the kind people who befriended them).

Forty-one ships that fought in World War II were named after North Carolina, the most famed being the battleship USS *North Carolina*. Randomly named after the Tar Heel State, it would be the first to serve in the war and would receive fifteen battle stars for its meritorious service in the Pacific Theater. Beyond its superlative name (and a few homeboys onboard), the state of North Carolina had no meaningful association with the ship. Despite this disconnect, loyal Carolinians were peculiarly unable to part with the battleship when it was scheduled for the scrap heap after the war. Eventually purchased from the navy with private donations, the USS *North Carolina* was moved to the port of Wilmington and currently serves as a well-loved naval museum; a testament to the pride all North Carolinians share in the men, women—and ships—who represent them.

1942: THE OUTER BANKS WAR

In 1942, German U-boat commanders lurking off the coast of North Carolina referred to their wildly successful target practice as "the Great American Turkey Shoot." Americans would come to call the spectacle "Torpedo Alley." Whatever you want to call it, it was a bloody massacre of American ships, and to avoid a panic, political leaders deliberately witheld the debacle from American newspapers.

For the residents of the Outer Banks, particularly Ocracoke Island, Avon, Cape Lookout and Cape Hatteras, the danger was all too real. Midnight blasts, house-shaking explosions, an occasional U-boat sighting (one fisherman almost rammed a U-boat that surfaced directly in front of his twenty-foot boat) and the fear of German invasion were a more-than-vivid reality.

The terror began shortly after the United States joined the fight against Japan and Hitler. Germany had arranged for a small fleet of submarines to systematically pick off merchant supply ships along the Atlantic coast. From a German standpoint, the Outer Banks of North Carolina proved to be an ideal killing ground—affording easy targets along well-known shipping routes, an absence of defensive weaponry and a complete and perplexing failure to respond to the threat. German submariners would remember the experience as the "happy time," when U-boats destroyed enemy vessels at will. Most often, U-boats ran out of torpedoes before they ran out of targets. In a period of eight months, the Germans sank almost four hundred ships off the North Carolina coastline, killing over five thousand mariners, most of whom were civilians.

Outer Bankers watched their pristine shorelines morph into oil slicks, their skies transform into billowing plumes of burning oil and their beaches become littered with ship debris and human corpses. They would become the only civilian community on the North American continent to come under prolonged attack by the Germans.

By late 1942, military forces had finally begun to mobilize, and over the course of the next few months, four U-boats were sunk along the Carolina coast (by an army bomber, a US Coast Guard patrol boat and two navy destroyers). With this abrupt setback, the Germans redirected their submarine crews to the North Atlantic, and the Outer Banks would see no further action for the remainder of the war. The brief and devastating "Great American Turkey Shoot" would add to the tragic lore of the Graveyard of the Atlantic and would temporarily hamper America's war efforts.

Too old to assist in the war effort, Van and Bill whiled away their retirement playing strategy games.

1943: FIRST NATIVE AMERICAN COLLEGE

We now interrupt World War II to bring you an important development: Pembroke State College for Indians. To wrap our minds around this unique piece of history, we've got to step back in time.

As you will certainly recall, after the Tuscarora War of 1711, most of the Tuscarora had been obliterated or assimilated, choosing to cohabitate with other tribes or moving to a small reservation in eastern NC. Over the course of time, the remaining Tuscarora in NC transformed themselves—by the irrepressible bonds of love—into a tribally challenged mix of Algonquian, Siouan, Iroquoian, African and European descendants. The resultant mixed breed, as some race-purist federal government might call them, became the self-appointed Lumbee Indians (calling on the Lumbee River, now called Lumber River, for their tribal identity). By the twenty-first century, the Lumbee would become the largest non-federally recognized tribe in NC.

In 1887, the Lumbee were growing concerned about their diminishing heritage (which was already considerably diminished). Complaining that their children "were receiving a black man's education," the Lumbee tribe successfully petitioned the NC General Assembly for the establishment of a teacher training college. The ensuing Croatan Normal School—named by whites after the dubious belief that the tribe were descendants of Croatan Indians and survivors of the Lost Colony—was formed to preserve the unique identity and cultural heritage of the Lumbee. The college endeavored to produce teachers who could teach in public schools specifically established for the Lumbee.

Over the next fifty-six years, the Croatan School would undergo four name changes, and by 1943, it had been designated Pembroke State College for Indians, located in Pembroke, NC. Pembroke State became the first Native American state-supported four-year college in the United States, a significant development for the state that had one hundred years earlier tried to expel the Cherokee.

In 1972, the college was incorporated into the UNC mega-educational system and today is simply known as the University of North Carolina at Pembroke. Having lost much of its original identity, tragically similar to the Lumbee, the university currently boasts about 6,200 students, of whom less than 15 percent are Native American. Unapologetically and politically incorrect, Pembroke still claims the name Braves for its athletic endeavors.

Things always got a little
dicey when the Braves
played the Mountaineers at home.

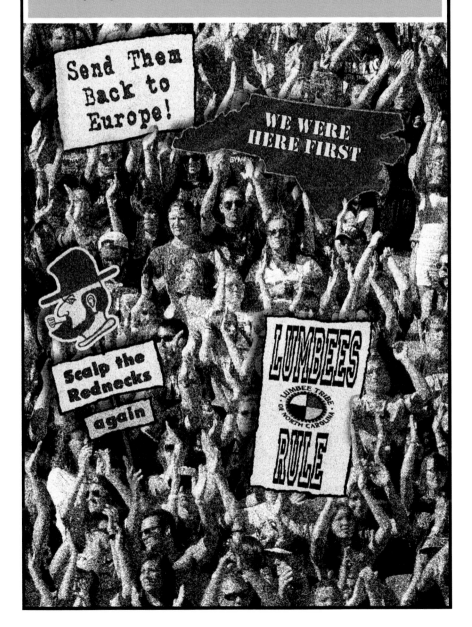

1945: World War II Legacy

By the end of World War II, NC had seen its workforce quadruple, its production skyrocket, its citizens—black, Native American, white, et cetera—enlist in waves of enthusiasm and its soldiers fight valiantly in every branch of the military and in every theater of battle. If one characteristic held true about the NC soldier or volunteer of World War II, it was his or her unbridled work ethic. They worked themselves into a frenzied lather of determination and sweat, in retrospect accomplishing what few of us could imagine today.

During America's early involvement in World War II, NC went freaking ballistic with military activity. At Fort Bragg, expansion efforts—boosted by a workforce of twenty-eight thousand—built 2,759 buildings in less than ten months, creating the largest military facility in the nation. In Elizabeth City, the Coast Guard founded its finest air station, designed to provide search and rescue operations, antisubmarine warfare and training facilities. It would become the largest Coast Guard Air Station in the United States. The Marine Corps commissioned and built the Cherry Point Air Station in Havelock, NC, training marines for service in the Pacific Theater and providing military support along the NC coastline. Its runways were so large that the Cherry Point Station would later become an alternate landing site for the NASA space shuttles. Another Marine Corps facility, Camp Lejeune, was built in Jacksonville, NC, its fourteen miles of beachfront becoming an ideal training environment for amphibious assault. Seymour Johnson Air Force Base was constructed near Goldsboro, NC, designed for training fighter pilots and bomber technicians. Today, it hosts two fighter wings and an air refueling wing of the US Air Force.

In summary, in less than three years, NC's workforce built four military bases from scratch and expanded Fort Bragg by eightfold. If you do the math, this would compare to building five cities (each containing fifteen thousand people) and the supporting infrastructure (water, sewage, utilities) in less time than it would take to develop one successful restaurant business. This level of determined hyper-construction had never been attained, or probably ever will be attained, in the history of the known universe. This would be NC's legacy in the fight against Hitler—not to mention its role in the spread of patriotic tattoo parlors (which currently stands at 360).

1947: The Journey of Reconciliation

Despite the great number of African Americans who had sacrificed their lives and livelihoods during World War II, when the dust of war had settled, it made little difference to the white legislators of NC and the southern United States. Blacks were still subjected to antiquated Jim Crow laws that relegated them to the status of second-class citizens. Forced to continue their postwar lives in a segregated society where access to white-only parks, hospitals, beaches, pools, restaurants and hospitals was denied, African Americans began gearing up for another kind of war.

Strangely, a feisty twenty-seven-year-old homemaker and a seemingly innocuous clause in the US Constitution would join together to sound the battle cry. In 1944, when traveling from VA to MD, Irene Morgan was arrested for sitting in a white-only section of a Greyhound bus. When the VA courts declared her guilty, she took her case to the US Supreme Court, where judges were forced to review the Commerce Clause. The clause allowed the federal government to regulate trade between states and, in an earlier Supreme Court interpretation, did not allow states to require segregation during interstate travel. In 1946, Irene Morgan won her case, and the battle for civil rights quietly, and proverbially, came to the front of the American bus.

Bolstered by the Morgan decision, in 1947, sixteen civil rights leaders (eight black and eight white) would take the next ride toward freedom. Calling it the Journey of Reconciliation, the group traveled on two interstate buses from Washington, DC, to Kentucky. Hoping to bring attention to the fact that southern states were not complying with the court's decision, whites sat in back and blacks sat in front (exactly opposite of what was allowed by southern Jim Crow laws). The group passed through VA uneventfully but were soon stopped in Chapel Hill, NC, where four men were arrested and three were sentenced to a **chain gang**. The presiding judge offered these revealing words to the white offender: "You can't come down here bringing your niggers with you to upset the customs of the South. Just to teach you a lesson, I gave your black boys thirty days, and I give you ninety."[11]

The case was appealed to the NC Supreme Court, which upheld the decision. The men would serve twenty-two days on the chain gang and were released on good behavior. The civil rights journey had just begun.

1955: Civil Rights Movement

No one could have guessed equal rights for African Americans would come to the southern states by way of a public bus system, lunch counters and football games—nor that North Carolina would be involved.

In 1955, pregnant fifteen-year-old Claudette Colvin refused to vacate her seat for a white patron on a crowded Montgomery, Alabama bus. She protested on the basis of her "constitutional rights." She was correct in doing so but was promptly arrested anyway. Nine months later, forty-two-year-old Rosa Parks repeated the offense and was also arrested. The resultant one-year Montgomery Bus Boycott led to an appeal of the original Colvin arrest. The US Supreme Court decision negated Alabama's segregation policy, and a US marshal informed the Montgomery mayor that his days of racism were numbered. Unfortunately, the marshal was wrong. Violence prevailed in Alabama, and after several murders and church bombings, segregation remained in full force. Once again, southern states defied the courts, and the federal government shrugged its benevolent, white shoulders.

In 1960, four black young people attending North Carolina A&T decided to initiate their own small protest against segregation. Sitting down at a whites-only lunch counter at a Greensboro, North Carolina Woolworth store, the four requested service. Management asked them to leave, but they ignored the request, stayed until closing and then returned the following day. By the fourth day, over three hundred people had joined the protest, and the sit-in movement quickly spread to Charlotte, Winston-Salem, Durham and Raleigh. Within six months, five more states had joined the party, and after losing thousands of dollars, Woolworth finally capitulated, desegregating its stores.

Inspired, civil rights leaders returned to the bus. In 1961, calling themselves the Freedom Riders, a new wave of riders headed into the Deep South, where more than 325 of the riders were eventually placed in jail (along the way, Charlotte, North Carolina, arrested a few, and citizens of Monroe, North Carolina, attacked black riders while the police watched). The Riders' movement would eventually ring the death bell of bus segregation and would inspire involvement in future civil rights campaigns that would bring Martin Luther King Jr. to the forefront of the African American civil rights movement.

In due course, these tumultuous events would bring equal rights to all blacks—but in another bizarre twist, it would be American football that finally began to overhaul southern attitudes toward the black community. Go team!

1957: Billy Graham

At the height of the civil rights movement, a young, skinny pastor from North Carolina stepped onto the scene. Hailing from Charlotte, the white Baptist pastor-turned-evangelist sought out the souls of men with no particular preference in skin color. Early in his Crusades (the name he gave his large, outdoor preaching events), Billy Graham began urging desegregation, once refusing to preach to a Jackson, Mississippi crowd if ropes separating blacks were not removed. In 1957, Graham invited Martin Luther King Jr. to speak in his sixteen-week New York Crusade that reached over two million. Graham's message, though not intended to promote racial equality, did so nonetheless. At his predominantly white gatherings, Graham preached that "the ground at the foot of the cross is level," and his audiences were no doubt influenced by his color-blind gospel.

Over the course of his fifty-seven-year career as a traveling preacher, it is estimated that Graham reached over 2.2 billion people, more than anyone in the history of Christianity. Few could argue that by the time he preached his last Crusade, Graham had become "the World's Pastor." No one in the twentieth century had a greater influence on spiritual thought, personal ethics, public policy, social issues and the cause of freedom than Billy Graham—a shocking revelation, considering his calling began in the "Colony of Rogues."

During his evangelist career, Billy advised twelve US presidents; preached in 185 countries; founded a magazine, radio and television show; created a weekly newspaper column; established a movie production company; and authored over thirty books. The man was on a mission, and despite numerous moral fiascos of his day, Graham maintained his integrity, humility and respect—perhaps one of his greatest accomplishments.

His admiration is still seen today, in churches, Christian camps, golf courses, barnyards and convention centers where he sojourned, many reverently displaying a plaque commemorating his presence (historically speaking, Americans will claim ownership of favorable leaders, role models or sport figures but for some reason deny any association with people like Benedict Arnold).

Today, Graham is memorialized in a $27 million museum in his hometown, which sports a talking cow, gift shop, interpretive exhibits and a few Disney-esque displays. According to some, Graham was unable to escape the rogue tackiness of his benevolent home state. When Billy was asked how he liked the tribute, he responded, "Too much Billy Graham."[12]

In an effort to raise more funds, the North Carolina chapter of Girl Scouts extended their tasteful limits.

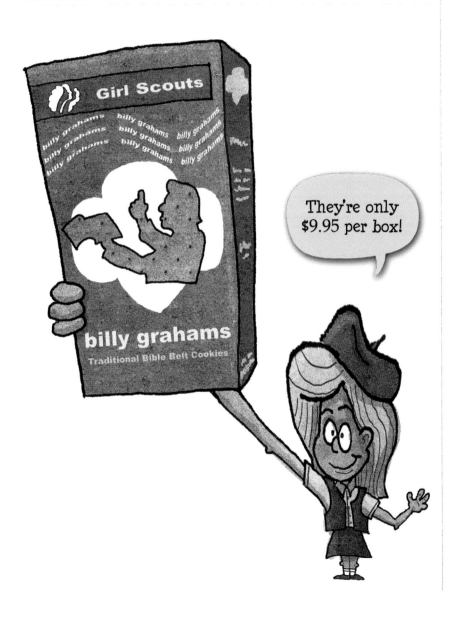

1957: THE HIGHLAND GAMES

On the morning of August 19, 1957, 1,500 people gathered at Grandfather Mountain, North Carolina, to drink beer, show off their new skirts and toss a few trees around. The unusual event—originally banned by the North Carolina legislature in 1870 for its drunken bouts of rowdiness and gambling—was the first of its kind in almost a century. Leave it to the Highland Scots to resurrect stylish dress.

The restoration of the Scottish Highland Games not only invigorated the plaid skirt business but also renewed interest in North Carolina's Scottish heritage—evidenced by the sizable turnout at the first Grandfather Mountain venue. Formulated by journalist Donald MacDonald from Charlotte and Agnes MacRae Morton from Linville (mother of Grandfather Mountain owner Hugh Morton), the event would ultimately become the largest gathering of Scottish descendants on the face of the planet. Today, annual attendance tops twenty thousand. The four-day event, utilizing the Scotland-like terrain of Appalachia, showcases Scottish kilts, food, dances, music, storytelling and everything else reminiscent of ye old Scottish homeland. The highlight of the gathering pitches individual combatants in footraces, caber competitions (tree tossing), weight chunking and other brawny endeavors that herald a Scot's ability to coordinate fairly difficult tasks while being slightly intoxicated. All in good fun, the Highland Games bring together the best (and worst) of North Carolina's Scottish heritage.

Although difficult to fathom, the coastal, Piedmont and mountain regions of the eighteenth century were so thoroughly settled by Scottish immigrants that today North Carolina contains more Scottish descendants than Scotland itself. Validating this historic development, in 1997, Governor James Hunt proclaimed April 6 as "Tartan Day" in North Carolina (the same day is also "National Tartan Day," commemorating a long list of Scottish contributions to our nation's work ethic, values and faith).

Today, the Grandfather Mountain Highland Games take place during the second weekend of July and are world renowned for their excellence in bagpiping, drumming, dancing and athletic competitions. So deep are North Carolina's Scottish roots that three more "Highland Games" have sprung up to accommodate the interest—taking place in Red Springs, Waxhaw and Charlotte.

The **Scotsman Toss** was always a crowd favorite.

1958: KLAN VERSUS LUMBEE

Founded in 1865 by six disgruntled former Confederates, the Ku Klux Klan would continue to advance a white supremacist mentality in the former Confederate states. Though the KKK was initially formed in Tennessee as a secret vigilante group terrorizing blacks, other groups would adopt the name and carry the legacy into every southern state. The Klan grew to become a four-million-man hate movement in the mid-twentieth century—its members dressing in cone-shaped, pointy hats and flowing white ropes—opposing blacks, Catholics, Jews and non-white Americans who didn't possess the correct coloration or support the Klan's agenda.

Unfortunately, North Carolina had its fair share of pointy-headed Klan members; at one point, the Tar Heel state claimed over ten thousand members, more than all southern states combined. These swelling ranks were due in part to a 1954 Supreme Court ruling that mandated the desegregation of all public schools. Perhaps nowhere was this decision more unwelcome than in Robeson County, North Carolina, where a tri-racial population—forty thousand whites, thirty thousand Native Americans and twenty-five thousand African Americans—effectively remained segregated within their own public schools. On the night of January 18, 1958, two of these groups would have the opportunity to face off in an old-fashioned brawl between whites and Native Americans.

It began when the local KKK in Robeson County got perturbed about two events involving Lumbee Indians: 1) a Lumbee family had moved into a white neighborhood and 2) a Lumbee woman was dating a white man. Hoping to intimidate the culprits, the Klan burned crosses in their respective front yards, a carryover of Scottish tradition (hence the Klan name) symbolizing the burning away of evil. Scheduling a rally five days later, the Klan hoped that the highly publicized cross burnings and forthcoming rally would further its cause and "put the Indians in their place." Thankfully, the opposite occurred.

Over one thousand Lumbee showed up for the late night rally and, on cue, promptly attacked the one hundred or so unsuspecting Klansman, shooting out the lone light bulb, firing guns in the air and chasing all the nervous white people away. Photographers already at the scene captured it all on camera, with two of the Lumbee later appearing in *Life* magazine with a KKK banner wrapped triumphantly around their middle. The rout galvanized the community against the KKK, and its numbers would forever diminish in Robeson County, North Carolina, and beyond. Today, the Lumbee annually celebrate the victory as "the Battle of Hayes Pond."

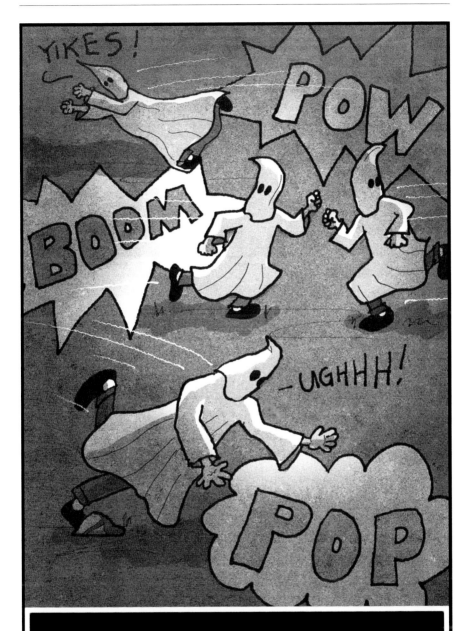

Living up to their Lumbee nickname, the Ku "Klutz" Klan tried in vain to escape the attack.

1959: Research Triangle Park

The past often lives on, quietly and often imperceptibly molding events and shaping lives. By the mid-1950s, NC's past economic struggles and cultural isolation continued to work their magic. Despite a growing tourist industry, improvements in education, an addictively productive tobacco industry and a prolific manufacturing sector, NC enjoyed the lowest per capita income in the United States. Recognizing this, college graduates—particularly scientists, entrepreneurs, engineers and technicians—were looking elsewhere for work, and the ol' "Rip Van Winkle" moniker was raising its sleepy head as a serious brain drain swept across the state.

In the midst of this "second exodus," a group of business leaders and educators began strategizing. Hoping to reverse the trend, they urged Governor Hodges to consider a notion that had been incubating for several years—a notion that would combine the strengths of UNC–Chapel Hill, NC State and Duke University, located within twenty-five miles of one another and conveniently forming a triangle. Together, they hypothesized, these institutions could be put to service in the development of a centrally located "Research Park"—a technological playground, so to speak, that linked universities, industry and community in an attempt to develop marketable ideas and technology-based economic growth (a mouthful of fun that could translate into high-paying jobs for NC).

Hodges, as expected of any politician, appointed a commission to study the idea. Over the next three years, the concept grew into a reality, as politicians, educators and industry came on board to form a nonprofit foundation to develop the Research Triangle Park (RTP). In 1959, the first major company, Chemstrand (which would later produce Astroturf), moved to RTP. In the years following, technology giant IBM (the park's largest employer with over eleven thousand workers), the National Institute of Environmental Health Sciences and a multitude of biotech and health industries relocated to the RTP. Over the next thirty years, the growth was exponential. The impact of this concentrated brilliance would change the economic and intellectual face of NC for decades (or at least until the next major hibernation).

Currently, the RTP has hosted over 245 company startups, developed 3,256 patents, employed over forty thousand workers and become one of the most prestigious and productive Research Parks in the world. At the fortieth-anniversary commemoration, Governor Hunt stated, "The success of this Park...has embolden[ed] us. We now believe we can do big things."[13] Big things, indeed!

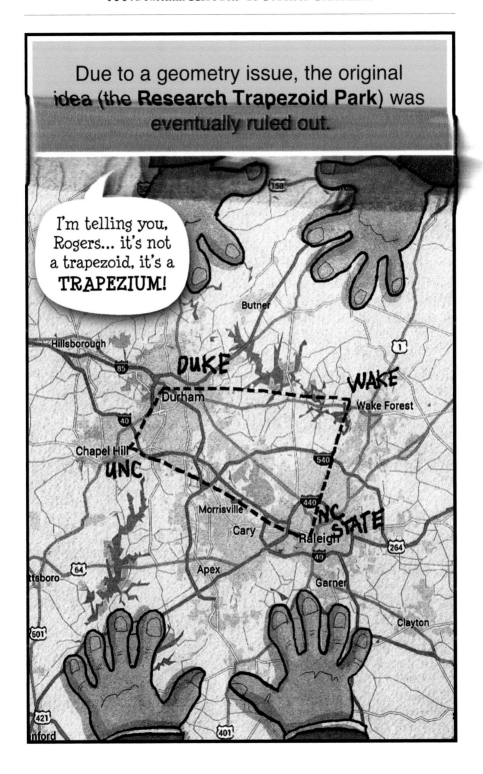

1960: *THE ANDY GRIFFITH SHOW*

As North Carolina belatedly merged itself with the twentieth century, a gangly, six-foot wanna-be-preacher-turned-schoolteacher sauntered onto the scene. Perhaps the only television star to be embraced by a North Carolina history book, Andy Griffith's career would span a lifetime and forever alter the collective perception of "back home" North Carolina.

Hailing from humble Mount Airy, Griffith began to develop his passion for acting while enrolled as a music major at UNC–Chapel Hill. During summer recesses, he performed as a cast member in the *Lost Colony*, an annual play commemorating our favorite colonists of Roanoke Island. After graduation, Andy taught music and drama at Goldsboro High School for several years while the development of his life-long public persona brewed on the backburner. In 1953, completely out of Nowheresville, Andy Griffith captured the attention of the nation with a comic single entitled, "What It Was, Was Football." Reaching number nine on the billboard charts, his country-bumpkin routine would launch him on a movie career (*No Time for Sergeants*), land him several Broadway plays and eventually plop him in a Danny Thomas TV sitcom segment that would morph into his role as the nation's favorite county sheriff in *The Andy Griffith Show* (*AGS*).

The *AGS* never placed lower than seventh in the Nielson ratings, ended at number one in its final (eighth) season, was ranked as the ninth-best show in American television history and, perhaps most telling, has never been off the air since its inception in 1960. The *AGS*, running twenty-four/seven on national and international networks for over fifty years, has been (and maybe, forever will be) the most-watched TV show in the history of couch potatoes.

Using a 1930s version of Mount Airy as his model, Griffith shaped the faux town of Mayberry as the iconic pastoral backdrop for his show, creating a lasting impression on impressionable digital minds. Quite unintentionally, Griffith's brilliant construction of Mayberry and its endearing characters left viewers with the distinct notion that the real North Carolina afforded the same contentment and virtues of small-town life. Ironically, while North Carolina struggled to pull itself out of a "backwoods economy," Griffith invited viewers to enjoy a North Carolina that had been gladly bypassed by the modern world. Griffith's version of North Carolina may have done more to grow its tourism industry than any other event in its history.

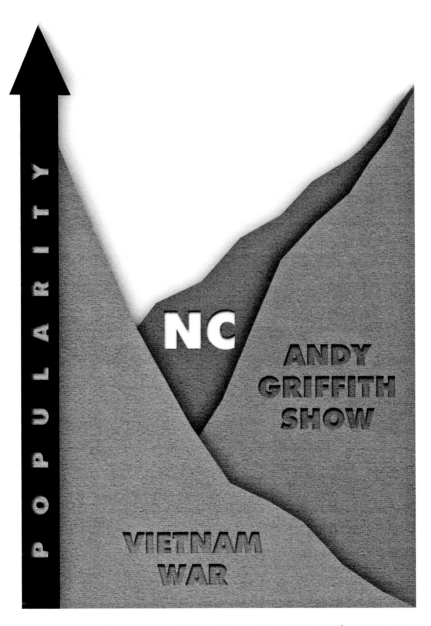

1971: NEW CONSTITUTION

In the one hundred years following NC's 1868 Constitution, voters had ratified sixty-nine amendments. Even so, by 1971 the Constitution had become so outdated and contradictory that it left lawmakers and judicial interpreters looking confused and ridiculous. In 1967, Governor Moore requested that the State Bar—the agency responsible for regulating laws—revise the state constitution. Finding the document in need of a zillion amendments, the group decided to simply upgrade the existing document with a rewrite. The General Assembly approved the draft, and in 1971, voters approved the new constitution by a narrow margin of 63 percent—proving once again that Carolinians approach change with caution.

The most revealing amendment to the new constitution involved a repeal of the "literacy test." Ratified in 1890, the literacy test required voters to interpret a small section of the constitution, proving that they could read and understand basic English. The underlying intent of the test was to prevent blacks from voting. If blacks attempted to vote, they were given impossibly difficult questions (whites were given easier questions), ensuring they would fail the test. Technically, the literacy test met the requirements of the US Constitution because it did not explicitly limit the rights of voters based on race. In reality, it was used to disenfranchise African Americans.

Although the General Assembly repealed the literacy test in the 1971 constitution, it failed to pass in the statewide election. Ultimately, it proved irrelevant in view of the US Civil Rights Act, which prevented its enforcement—but it clearly illustrated that in 1971, many North Carolinians were still hesitant to pursue racial equality.

1971: THE WILMINGTON TEN

As the largest slave port in North Carolina, Wilmington had harbored a sizable portion of African Americans and possibly a larger portion of long-standing racial prejudices—former slave cultures often require a few centuries of tumult and tension in the process of ousting discrimination. Wilmington boasted the lion's share of North Carolina's racial tension and the '60s and '70s era would bear this out.

After the Martin Luther King assassination in 1968, the nonviolent tactics King had so adamantly supported suddenly seemed ineffective to many civil rights activists. Eager for a less-lengthy journey toward equality, blacks in Wilmington began voicing their anger. After steps were taken to integrate Wilmington schools, violence escalated. White businesses were fire-bombed, and violent clashes between blacks and whites became more frequent. Hostilities reached a boiling point in 1971, when black students boycotted school attendance and two downtown white businesses were burned to the ground. KKK members were soon patrolling the streets, and angry threats led city officials to consider a citywide curfew. Their delayed action would later haunt them.

On the night of February 6, another white business was fire-bombed, and when firefighters reported to the scene, snipers hiding in an adjacent church fired on them. During the ensuing standoff, a young black man and an older white man were killed in the exchange of fire. The National Guard ended the two-day standoff, and ten people—nine black men and one white woman—were eventually convicted. The "Wilmington Ten," as they came to be known, were sentenced to a combined 282 years.

Serving three to seven years, the Wilmington Ten became a media magnet for the subject of prejudice and racial hatred in North Carolina, and their questionable convictions were eventually commuted and then pardoned. By 2012, surviving members of the Ten had been compensated by the state for their prison time ($50,000 per year), and the controversy concerning their convictions still finds ample media coverage today. Interestingly, in the national push to exonerate the Ten, the original perpetrators of the violence, whoever they were, were completely forgotten, and apparently tired of the whole affair, the City of Wilmington pursued no convictions.

The saga of the Wilmington Ten would highlight deeply entrenched prejudices and ineffective strategies for resolving them. For the city of Wilmington, the shadow of slavery would linger into the twenty-first century.

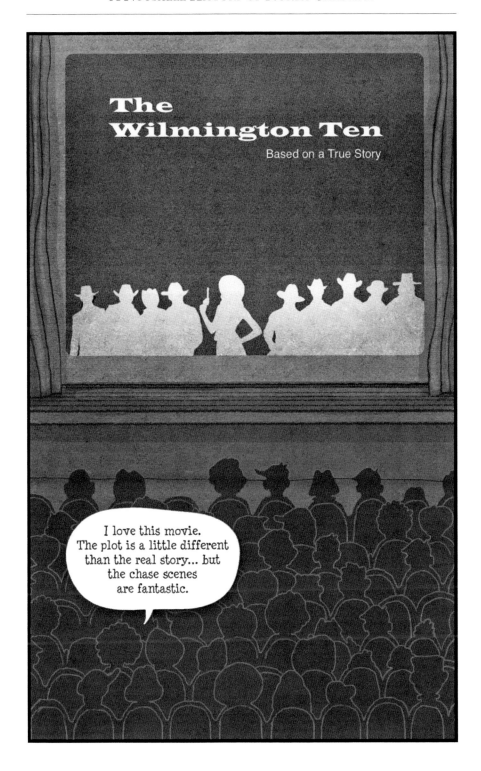

1984: HUNT AND HELMS

As North Carolina approached the postmodern era, two of its polar opposite politicians emerged on the national scene. Their memorable political battle in 1984, costing $26.3 million and becoming the most expensive Senate race in Tar Heel history, highlighted qualities that in many ways defined the character of North Carolina and its ongoing struggle to reconcile its past with its present.

Hailing from Wilson, North Carolina (interestingly, from the east), Jim Hunt would become the longest-serving governor in the state's history, serving a total of sixteen years over a period spanning from 1977 to 2001. As a Democratic governor, Hunt would exemplify a sophisticated liberal stance, dedicated to educational and economic progress with an emphasis on equal rights for African Americans, concern for the environment and moderation in social issues. Hunt would be particularly remembered for his reforms in North Carolina education.

A native of Monroe, North Carolina (decidedly western), Jesse Helms would become the longest-serving senator in the state's history, serving thirty consecutive years from 1973 to 2003. As a Republican senator (the first since 1903), Helms conveyed a grandfatherly, southern demeanor, with an ultra-conservative approach that denounced tax-and-spend ethics, decried the "immoral demise of the Democrats," vehemently opposed equal rights for blacks and relied heavily on fear-based cold war rhetoric. Nicknamed "Dr. No," Helms opposed any legislation that was deemed "liberal" and fought for the industrial development of his home state.

These two opposing forces squared off for the 1984 North Carolina Senate race, which not only offered extremely opposite ideologies but also, more interestingly, showcased the most highly publicized, no-holds-barred, mud-slinging campaign in US history. Characterizing Hunt as a liberal, pro-union, anti-military, middle-of-the road pansy, Helms's ad campaign would have made Donald Trump blush. Hunt opted to retaliate, portraying Helms as a right wing, industry back-scratcher, supported by tobacco and a racist-driven agenda. Of course, the media loved it, and the nation was drawn into North Carolina's awkward moment.

After a long, bitter campaign, Helms emerged the victor, with a narrow 52 percent of the vote, and would continue his Senate reign for the next eighteen years, finally retiring when health problems forced his hand. The Hunt-Helms saga would reiterate to the nation that North Carolina was a deeply divided state, torn between progressive ideas and deeply rooted southern values—and unafraid to throw a little mud.

Prior to the debate, both candidates ate a hearty breakfast.

1990: The Conservation Movement

The conservation movement—a movement to reverse unsustainable resource use—began as early as the late 1700s in North Carolina, as hunting practices began to decimate deer populations. Lawmakers established hunting seasons to protect the species and to prevent waste, but it took one hundred more years of unrestricted resource depletion for its citizens to see the devastating effects of unchecked growth—air and water pollution, deforestation, soil erosion, endangered species and mounting health concerns—to pursue a course of correction.

By the 1990s, owing to a long procession of hippies, hikers, hunters, simple-living advocates, health-conscious gurus, outdoor enthusiasts, writers, philanthropists, conservation organizations and alarmed citizens, North Carolina had grown to embrace a grass-roots approach to environmental concerns. Having set aside a national park, twenty-seven state parks and twelve wilderness areas, North Carolina's nature-loving populace had effectively waged war on industrial growth, urban development and the occasional misguided politician.

By the twenty-first century, North Carolina's biggest environmental challenges were auto emissions (Great Smoky Mountains National Park is ranked one of the most polluted national parks in the country), habitat destruction due to population growth and industrial abuses, toxic waste from large-scale farming, water-quality issues related to industrial practices, air pollution from coal-burning electrical plants and mismanaged radioactive dumping sites.

Addressing these problems, currently sixty-three environmental organizations are operating full-throttle—surely on biofuel—to keep North Carolina beautiful. Relying heavily on fundraising campaigns, volunteer labor, education, marketing strategies and political involvement, these organizations have been surprisingly successful in creating awareness and delivering the goods: a cleaner, safer, wilder North Carolina. National organizations like the Sierra Club, Audubon Society and the Nature Conservancy have also played pivotal roles in protecting and improving habitats along mountain trails, Piedmont rivers and coastal waterways.

North Carolina's conservation legacy can best be experienced on the fly, as millions of annual tourists and local Carolinians would attest—enjoying its magnificent beauty and incredible variety during all four seasons of the year.

Charlie and Melissa pack for their dream
vacation in the wilds of North Carolina.

1999: THE HURRICANE STATE

Recalling its protruding shoreline, the lack of safe harbor and the treacherous waters off the Carolina coast, it should come as no surprise that hurricanes would find the North Carolina coastline appealing. Dating back to the first official hurricane records kept in 1851, North Carolina has experienced forty-eight landfall hurricanes, ranging from Category 1 (74–95 miles per hour) to Category 4 (130–156 miles per hour). Owing to its protruding coastline (the Outer Banks) and the propensity for tropical storms to develop in the south Atlantic and then travel northwestward, North Carolina has had its fair share of high winds and generous rainfall, averaging a hurricane about every three and a half years.

Rating fourth in historical hurricane performance, behind Florida, Texas and Louisiana, North Carolina has experienced a total of $14 billion in damages and lost over one thousand lives to hurricanes. If anyone is counting, that's minuscule compared to dimwitted tobacco damages in the Old North State. Nonetheless, these August-to-October high winds are worth noting, particularly if one has ever experienced the sheer terror of a North Carolina hurricane.*

In terms of physical damage and loss of life, North Carolina's worst recorded hurricane came ashore in 1999. Appropriately nicknamed Floyd, in a vengeful, redneck-sounding sort of way, he would put entire communities under water, destroy more than eight thousand homes, drown over thirty thousand hogs, kill fifty-two people and create $6 billion in damages. Making landfall near Wilmington and heading northwest, what made Floyd particularly damning was its potent rainfall, with some communities receiving sixty straight hours of downpour.

Floyd's 127-mile-per-hour winds (measured at landfall) were matched by North Carolina's five other record-setting hurricanes: Hazel (150 miles per hour, 1954), Donna (110 miles per hour, 1960), Hugo (140 miles per hour, 1989), Fran (115 miles per hour, 1996) and Irene (105 miles per hour, 2011). Each wreaked havoc in its own unique, antagonistic way and reminded Carolinians that hurricanes will continue to play a role in the Tar Heel State.

*My wife and I endured a North Carolina hurricane while living in a Native American tipi—but that's **another story**.

2000: Barbecue

As we arrive at the twenty-first century of our North Carolina story, glancing back on almost three centuries of impassioned conflict between eastern and western portions of the state, it is fascinating to note that the last bastion of hostility would revolve around a culinary preference.

In 1540, the overly invasive Hernando De Soto introduced hogs to Florida and Alabama. In 1607, the Jamestown settlers would repeat the experiment. Within a century, hogs were thriving in the southern colonies, and barbecued pork (requiring the roasting of said creature over an open fire) became an esteemed and tasty tradition. As this meal became known simply as "barbecue" (also fondly spelled barbeque, b-que or BBQ), North Carolina came to be the second-highest producer of hogs (Iowa is first), with two unique styles of hog seasoning evolving over time. Eventually characterized as *Eastern-style* versus *Lexington-style* (also known as *Western-style*),* respective barbecue lovers came to cherish their particular version while adamantly disdaining the opposing flavor—and the distasteful people associated with that flavor.

Eastern-style utilized the whole hog, with an ample portion of thin, stout, brownish sauce—a vinegary-peppery-sugary concoction. Lexington-style considered only the pork shoulder worthy of consumption, smothering it with a sweet red sauce that incorporated a tomato base (typically ketchup) seasoned with a mild dose of vinegar and pepper. As descriptions suggest, these are vastly different flavors, with a variety of spices further complicating the distinctions (salt, cayenne pepper, onion powder, garlic, nutmeg, molasses, brown sugar, Cheerwine or moonshine).

By the second millennium, as one can easily smell, North Carolina had become a barbecue-crazed state, boasting hundreds of BBQ establishments, no fewer than twenty-five annual cook-offs, an official North Carolina Barbecue Society and an equal frenzy for sweet tea, cole slaw and hush puppies, the perfect complements. Perhaps an indication of just how far North Carolina has progressed in sorting out its estranged past, the lowly hog, and how it should be seasoned, has become the final—and mostly humorous—battleground for east-west squabbling.

*Two centuries earlier, everything west of Fayetteville was considered western North Carolina and vice versa for the east. Taking this fact into consideration, Lexington was once considered in the western portion of the state (a strange geographical consideration today, as moderns consider western North Carolina the region incorporating the Appalachian Mountains, generally originating at the foothills in Morganton and moving west).

Some North Carolina hog farmers are very strategic in regard to the fate of their hogs.

In 2006, *House Bill 21* and *Senate Bill 47* were introduced, sparking controversy over which style barbecue would become the "Official Barbecue" of NC. Both bills were defeated.

2010: TODAY'S TAR HEELS

For centuries, NC has been populated by an assortment of cultures. A quick review reminds us that Native Americans, Spanish, English, African, French, Scots-Irish, German, Swiss and Welsh settled its Coastal, Piedmont and Appalachian regions. But the last few decades have precipitated a far more diverse population, luring immigrants from more than one hundred countries.

NC is also experiencing an unprecedented surge in population growth. The substantial influx has expanded urban areas beyond capacity—in the past fifty years, NC has doubled in population—extending cities into rural areas and neighboring counties. NC's largest cities include, in order of density: Charlotte, Raleigh, Greensboro, Durham, Winston-Salem and Fayetteville, ranging from just under 1 million to 210,000, respectively. These numbers reflect a traditional characteristic of NC: it possesses very few large cities while enjoying an abundance of rural America (two-thirds of NC's population inhabit the middle one-third of the state, with 85 percent of its cities claiming fewer than 10,000 people).

In case you haven't noticed, rural populations tend to possess their own unique, persistent cultures—cultures that are distinctly different from the "big city" (think *Beverly Hillbillies*). Although a few large cities will continue swallowing their pastoral surroundings—with native city-dwellers and invading immigrants accomplishing the task—rural/big-city polarity will remain a mainstay of NC, making it a pleasing, and occasionally awkward, place to live, work and play.

Ethnically, NC is changing. Formerly employed as migrant workers in the state, in the '90s Hispanics pursued full-time jobs and quadrupled their numbers. Today, they are the fastest-growing ethnic group in NC, making up 9 percent of the population (De Soto would be proud, but the government is not, estimating that 65 percent of the almost one million Hispanics in NC are illegal immigrants). Meanwhile, immigrants from India and Southeast Asia trickle into metropolitan, job-rich areas, accounting for 2 percent of the population, and migrants from the Northeast, Florida and California (generically called Yankees and comically challenged by southern-ese) continue to invade big cities and retirement communities. Accounting for the rest of the population: whites, 67 percent; African American, 20 percent; Native American, 2 percent (estimates from highly paid demographic guessers).

These numbers reflect Carolina's checkered past, its alluring charm and its mutating, bipolar populace—accommodating poor and rich, redneck and city-slicker and everything in between—legal or illegal.

North Carolina Clogging/Quilting League
All Competitions at 7:00 pm*

Bat Cave	vs	Hickory	Nov. 5
Old Trap	vs	High Point	Nov. 7
Horneytown	vs	Jacksonville	Nov. 9
Townsville	vs	Salisbury	Nov. 12
Whynot	vs	Wilmington	Nov. 14
Institute	vs	Durham	Nov. 16
Half Hell	vs	Greenville	Nov. 22
Lizard Lick	vs	Charlotte	Nov. 24
Meat Camp	vs	Burlington	Nov. 27
Nags Head	vs	Cary	Nov. 29
Tick Bite	vs	Greensboro	Nov. 30
Toast	vs	Gastonia	Dec. 2
Black Ankle	vs	Raleigh	Dec. 3
Shelmerdine	vs	Kannapolis	Dec. 5
Chocowinity	vs	Winston-Salem	Dec. 7
Big Lick	vs	Asheboro	Dec. 8
Fuquay-Varina	vs	Monroe	Dec. 10
Goat Neck	vs	Fayetteville	Dec. 13
Cooleemee	vs	Asheville	Dec. 15
Hasty	vs	Wilson	Dec. 16
Pumpkin Center	vs	Elizabeth City	Dec. 18
Poor Town	vs	Chapel Hill	Dec. 19
Duck	vs	Mooresville	Dec. 21
Bee Log	vs	Concord	Dec. 22
	Championship		Jan. 7

* All teams must play traditional music and wear appropriate clogging
shoes while quilting. Please be careful, dancing with sewing needles
can be dangerous.

The clogging/quilting schedule revealed a fascinating fact about North Carolina.

2018: The New "Old North State"

As *A Nutshell History of North Carolina* draws to a close, it would be important for the reader to recognize the effect of rapid change on the face of our planet—and in particular, the face of NC. With access to vast energy reserves, reliable machinery, brisk transportation, high-speed Internet, global trade and Starbucks, by 2018 NC had been transformed from a sleepy, struggling southern state to a major economic force—all within a span of fifty years. Looking back on our story, this should come as somewhat of a surprise. Change has come slow to NC. Its people are cautious and measured, its terrain somewhat isolated, its history convoluted, conflicted and plodding. Yet here we are: a twenty-first-century Carolina with strong connections to the past and an emerging economy that defies tradition.

Today, while NC holds firm to its agricultural roots, dominating the tobacco, sweet potato and Christmas tree industries, its information technology sector is second to none, leading production in semiconductors, hardware and software and employing almost ninety thousand people. Hog and turkey production remain high, ranking second in the nation, while financial services have become one of NC's leading fields, with Charlotte ranking second in national banking headquarters (this money-loving city offers twenty-five banking headquarters with over 3,500 branches). Furniture and textiles industries continue to redesign themselves; the craft beer industry (and associated hops production) is developing a strong following, while biotechnologies and pharmaceuticals are surging forward, currently positioned at fifth nationally.

The transition from the old economy (labor-intensive industries) to the new economy (knowledge-based, service-related industries) has been neither smooth nor complete, as NC appears to maintain a firm grasp on both paradigms and perhaps will continue to do so. Aiding the rapid economic plot twist has been a state that offers incredible natural diversity; raw, engaging beauty; a moderate climate; a friendly lot of hardworking folks; a reasonable cost of living; a substantial educational presence (fifty-eight community colleges, sixteen university campuses and thirty-six private colleges); a massive military presence (which consumes a respectable amount of bacon); and a fairly good housing market. All totaled, NC is positioned to continue its growth in old and new directions.

Although its isolationist birthright has been shorn, its rogue, proud, "don't mess with us" legacy will surely continue to shape its future.

I'm a Tar Heel born, I'm a Tar Heel bred,
and when I die, I'll be a Tar Heel dead.

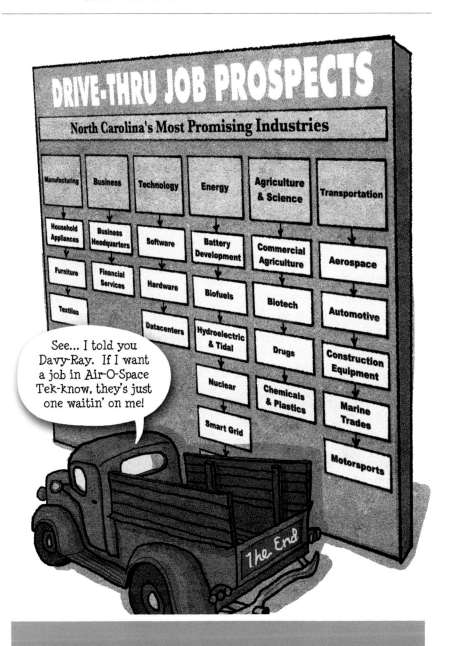

Davy-Ray and Maggie dropped by the
Drive-Thru Job Prospects, updated monthly,
to check on their future in North Carolina.

GLOSSARY

Another story: In reference to the "tipi in a hurricane" event (see "The Hurricane State"), years ago my wife and I were building a small cabin while experimenting with life in a Plains Indian tipi. Staking our claim in a remote corner of western North Carolina, we lived in the tipi for one year while our cabin slowly materialized. In the early spring of 1993, after a making its way from the coast, a rare hurricane showed up in the mountains. Unannounced, it dropped two feet of snow and swirled it around in ninety-mile-per-hour winds. Dubbed the "Storm of the Century" by Carolinians, we went sleepless and terrified into the dark night. By the time the winds dissipated and the light dawned, we had discovered that tipis are pretty darn storm proof—although they don't do a whole lot to calm your nerves.

Bushwhackers: A term used to describe pro-Union civilians who attacked Confederate forces, individuals or families in rural areas. Owing to the non-military nature of these groups, whose attacks were often fueled by revenge or with criminal intent, the Confederate military response was complicated and often brutal.

Carpetbaggers: During the Reconstruction era (1865–77), this term was used to describe a Northerner who had moved into the Southern states to support and implement the Republican strategy for rebuilding the South. Sixty carpetbaggers were elected to Congress during this period, and they included a majority of governors who had been designated by Northern Reconstruction terms. The expression originated with carpet bags—

cheap luggage that resembled a large carpet-lined purse—that were often carried by the newcomers.

Chain gang: A pejorative term used to describe a group of prisoners who are chained together while performing manual labor as a form of penal punishment. Introduced after the Civil War, chain gangs are now illegal in all US states except Arizona.

Cherokee Reservation: Also called the Qualla Boundary, the Cherokee Reservation comprises a tract of land in Swain, Jackson and Haywood Counties—and noncontiguous sections in Cherokee and Graham Counties—that belongs to the Eastern Band of Cherokee Indians. Unlike most Native American reservations, the Qualla Boundary was not established on federal land but was purchased by the Cherokee (yes, the Cherokee had to buy back their own land). Owing to this fact, the Qualla Boundary is legally a "land trust" rather than a reservation and is overseen by the Bureau of Indian Affairs.

Civilian Conservation Corps (aka CCC): A public relief program founded by US president Franklin Roosevelt in the early twentieth century. The CCC was designed as a way to provide jobs to unemployed young men who were trying to recover from a deep US economic depression. The CCC took on projects that involved the conservation and development of natural resources on rural lands owned by federal, state and local governments—projects included tree planting, road and trail building, firefighting, restoration of historic battlefields, park building and fish stocking. Over three million men served in the CCC during its nine-year history.

Committee of Safety: During the American Revolution, these were local committees of Patriots that were designated to bolster Patriot fervor, relay communications and make clandestine government decisions for the colonies. They eventually collected taxes and assisted in the recruitment of soldiers. Apparently, they also made Americans feel safe.

Cooper: A highly skilled craftsman who builds casks, drums or barrels out of wood (although for some odd reason, it seems like he or she should have been using copper instead).

Feudal Serfdom: Developed during the Middle Ages, this is a system in which serfs (peasant workers) who occupied a plot of land were required to work for the owner—usually a wealthy landowner or English lord—in return for protection and the right to utilize the land for food. Basically a form of bondage, the system gave the serf no career options and forced him to live out his life in service to the landowner—tons of fun!

Good Roads Movement: Eager for better roads in the late nineteenth century, bicyclists morphed their efforts into a national political movement advocating for good roads in and around rural communities. The movement's main goal was to educate construction crews in proper road-building technique and to help rural populations gain the necessary clout to receive government assistance for road building. By attaching themselves to the Good Roads Movement—promising good roads to small communities—politicians found eager supporters.

Great Wagon Road: A term used to describe a former Indian trail (the Warrior's Path) that was eventually converted to a wagon road by settlers traveling from Pennsylvania to North Carolina. It was considered the most traveled road in colonial America. Today, US Route 11 follows much of the old Great Wagon Road.

International Biosphere Reserve (IBR): Designated by the United Nations Educational, Scientific and Cultural Organization (UNESCO), an IBR area is chosen based on its ability to demonstrate and protect a balanced relationship between people and nature.

Jim Crow: Not an actual person but a term used to describe state and local laws that were used to enforce racial segregation in the South. Named after a popular nineteenth-century song, "Jump Jim Crow," sung by a white actor dressed as a black man, the song and dance presented a stereotypical view of southern African Americans. The term "Jim Crow" became a pejorative term that personified government-sanctioned racial oppression. Jim Crow laws remained in force until 1965.

Longhunter: An eighteenth-century hunter and trapper who made extended trips into the frontier in order to make a living. Often gone for up to six months at a time, longhunters were not known for being great family men—or for being good at anything else during hunting season.

Manifest Destiny: A widely held belief in the nineteenth century that American pioneers were destined by God to expand their territory across the entire North American continent. Despite the fact that others possessed the land the Americans expected to eventually occupy (Native Americans, British, French, Spanish), champions of Manifest Destiny believed that it was their providential right to take the land based on their redeeming mission (to transform the conquered into virtuous Americans—or kill them in trying).

Mercenaries: In short, hired guns. These individuals participated in armed conflict in order to receive a paycheck. Not your most motivated soldier, a mercenary usually had no political or emotional ties to the group he was fighting for.

Minutemen: American colonists who served in local militias to fight the British during the American Revolution. Minutemen were usually self-trained and self-equipped and ready to serve on "a minute's notice."

Naval stores: Products derived from pine resin that were most often used in the building and maintaining of ships. These items might include varnish, paint, turpentine, pitch and pine caulk (made with hemp and resin and used to fill gaps between ship planks). The term is no longer in common use.

Overmountain Men: American frontiersman who resided west of the Appalachian Mountains and offered their military assistance during the American Revolution. Hailing from the western portions of Virginia and North Carolina (what is now Tennessee and Kentucky), these men were essential to the American victory at the Battle of Kings Mountain.

Quakers (aka, Religious Society of Friends): A movement founded in seventeenth-century England that broke away from the Church of England in order to practice its version of Christianity. Its focus was on developing a personal relationship with God and maintaining strict inner and outer purity—which sometimes expressed itself in the over-utilization of such words as "thee" and "thou."

Reconstruction: The period immediately following the American Civil War (generally 1865–77) in which the Southern states that had seceded from the Union were considered for readmission. In order to qualify, states had to comply with a strict set of conditions, including approval of the Thirteenth and Fourteenth Amendments, ensuring freedom and political equality for African Americans. During this period, Southern states were estranged from the Republican Party (which attempted to enfranchise blacks) and aligned themselves with a white-supremacist Democratic Party. This period was also associated with the economic rebuilding of the South, which had been devastated by the war. Many historians considered "Reconstruction" a failure due to the fact that the Southern economy remained in poor condition and Southern states eventually enacted their own local laws (Jim Crow laws) to override Northern attempts to empower blacks.

Red Shirt: A self-described term for white-supremacist terrorist groups that were active in the late 1800s. First appearing in Mississippi in 1875, they adopted red shirts to appear more threatening to African Americans and their sympathizers. Often engaging in violence—and even murder—the Red Shirts operated openly and were more organized than their secretive brothers in arms, the KKK. The goal of the Red Shirts was to restore the Democrats to power in the Southern states.

Rhododendron: A woody, evergreen plant of the heath family, widespread throughout the Appalachians. It is typically found along creek beds and shady hillsides, growing in tangled, impenetrable masses. It is particularly fun to travel through a thicket of "rhodo" while toting a backpack.

Scalawag: A derogatory term used by Southern whites to describe neighbors who supported the Republican Party and Reconstruction efforts after the Civil War. Scalawags, a word we might use today to describe a particularly notorious pirate, were considered traitors to the Southern cause.

Three-axis control: An aeronautical engineering feat, first accomplished by the Wright brothers, which provided maximum in-flight control of a flying machine. Three-axis control incorporated wing warping (for lateral roll), forward elevators (for lateral motion) and rear rudder yaw (for side-to-side motion).

Thru-hiker: Although inauspiciously misspelled, thru-hiker is the term applied to a backpacker who has hiked a long-distance trail from end to end. Associated with the Appalachian Trail in North Carolina (and hopefully the Mountains-to-Sea Trail when it is completed), a thru-hiker is held in great awe and respect—especially if he or she can share a few good stories.

Underground Railroad: A secret network of routes and safe houses developed by abolitionists sympathetic to the cause of enslaved African Americans. Usually beginning in the Southern states and headed north to free states and Canada, the "Railroad" aided over 100,000 slaves in their escape.

Wachovia: Eventually the name of a corporate financing giant that was founded in Winston-Salem and named after the Moravian territory. Unfortunately for the Moravians, in 2008 it merged with Wells-Fargo Bank, based out of California.

NOTES

1. Sanford, *Daniel Boone*, 44.
2. Mammen, "*North Carolina Gazette.*"
3. NC Digital History, 2.7.
4. Powell, *North Carolina*, 245.
5. Yannessa, *Levi Coffin*, 24.
6. Moulton, *Papers of Chief John Ross*, 76.
7. Ehle, *Trail of Tears*, 275.
8. Zinn and Arnove, *Voices*, 144.
9. Trotter, *Silk Flags*, 49.
10. Brundage, *Where These Memories Grow*, 98.
11. Baldwin and Dekar, *Inescapable Network*, 117.
12. Simon, "Billy Graham."
13. Link, *Seed to Harvest*, 37.

BIBLIOGRAPHY

Baldwin, Louis V., and Paul R. Dekar. *An Inescapable Network of Mutuality: Martin Luther King Jr. and the Globalization of an Ethical Ideal*. Eugene, OR: Cascade Books, 2013.

"Battle of Guilford Courthouse." The History Channel. November 2014. http://www.history.com/topics/american-revolution/battle-of-guilford-courthouse.

"The Beginning of North Carolina's Schools and the Literary Fund." North Carolina State Board of Education. September 2014. http://stateboard.ncpublicschools.gov/about-sbe/history/chapter-one.

Billinger, Robert D. "World War II." NCPedia. December 2014. http://ncpedia.org/world-war-ii.

Brundage, Fitzhugh. *Where These Memories Grow: History, Memory and Southern Identity*. Chapel Hill: University of North Carolina Press, 2000.

"Chapel Hill Remembers." Fellowship of Reconciliation. November 2014. http://forusa.org/blogs/ruby-sinreich/chapel-hill-remembers.

Cockrell, David L. "East-West Rivalry." NCPedia. July 2014. http://ncpedia.org/east-west-rivalry.

Cohn, Scotti. *It Happened in North Carolina: Remarkable Events That Shaped History*. Guilford, CT: Glove Pequot Press, 2010.

Cordingly, David. *Under the Black Flag: The Romance and Reality of Life Among the Pirates*. New York: Random House, 1996.

Ehle, John. *Trail of Tears: Rise and Fall of the Cherokee Nation*. New York: Anchor Books, 1989.

"Fort Necessity: The Cherokee and the French and Indian War." National Park Service. September 2014. http:// www.nps.gov/fone/learn/ historyculture/upload/FONE-Cherokee-and-the-FandI-War.pdf.

"Frequently Asked Question." Appalachian Trail Conservancy. December 2014. http://www.appalachiantrail.org/hiking/thru-section-hiking/faqs.

"George Vanderbilt." Open House: The Official Blog of Biltmore. November 2014. http://www.biltmore.com/blog/article/george-vanderbilt.

"Gold Fever: The History of Gold in North Carolina." University of North Carolina TV. September 2014. http://goldfever.unctv.org/history.

Graham, Nicholas. "August 1751: North Carolina's First Newspaper." This Month in North Carolina History. August 2014. http://library.unc.edu/ wilson/ncc.

"The Great Depression." The History Channel. October 2014. http:// www.history.com/topics/great-depression.

"Great Smoky Mountains." National Park Service. December 2014. http:// www.nps.gov/grsm/learn/historyculture/people.htm.

Herdon, Charles A., III. "Joseph Hyde Pratt." NCPedia. December 2014. http://ncpedia.org/biography/pratt-joseph-hyde.

"Historic Bath: John Lawson." North Carolina Historic Sites. August 2014. www.nchistoricsites.org/bath/lawson.htm.

"Kings Mountain." National Park Service. September 2014. http://www. nps.gov/kimo/index.htm.

Kremer, William. "James Buchanan Duke: Father of the Modern Cigarette." BBC News Magazine. October 2014. http://www.bbc.com/news/ magazine-20042217.

"The Life of Daniel Boone." Boone Association. November, 2014. http:// www.booneassociation.com/timeline.html.

Link Albert N. *From Seed to Harvest: The Growth of Research Triangle Park.* Research Triangle Park, NC: Research Triangle Foundation, 2002.

"Longleaf Pine." North Carolina Forest Service. July 2014. http:// ncforestservice.gov/managing_your_forest/longleaf_pine.htm.

MacLaurin, Melton. "The History of the State Fair." NCPedia. December 2014. http://ncpedia.org/government/fair/history.

Mammen, Edward H. "North Carolina Gazette." NCPedia. September 2014. http://ncpedia.org/north-carolina-gazette.

McCullough, Gary L. *North Carolina's State Historic Sites.* Winston-Salem, NC: John F. Blair Publisher, 2001.

Mobley, Joe A. *The Way We Lived in North Carolina.* Chapel Hill: University of North Carolina Press, 2003.

Moulton, Gary. *Papers of Chief John Ross*. Norman: University of Oklahoma Press, 1985.

"New Deal." The History Channel. October 2014. http://www.history.com/topics/new-deal.

"North Carolina and Tobacco." Public Broadcasting System. October 2014. http://www.pbs.org/pov/brightleaves/special_tobacco_timeline.php.

"North Carolina Commerce and Tourism: Annual Report." Visit NC. January 2015. https://www.nccommerce.com/tourism/about-us/annual-report.

"North Carolina Digital History." Learn NC. January 2015. http://www.learnnc.org/lp/projects/history.

"North Carolina Highway Historical Marker Program." North Carolina Department of Cultural Resources. November 2014. http://markers.ncdcr.gov/Home.aspx.

"North Carolina History." University of North Carolina: North Carolina History. July 2014. http://nchistory.web.unc.edu.

"North Carolina's Research Triangle Park." North Carolina Biotechnology Information. January 2015. http://www.ncbi.nlm.nih.gov/books/NBK158811.

"A Parkway Built When Stimulus Money Was Popular." National Public Radio. November 2014. http://www.npr.org/templates/story/story.php storyId=130473170.

Parramore, Thomas C., and Douglas C. Wilms. *North Carolina: The History of an American State*. Englewood Cliffs, CA: Prentice-Hall, 1983.

Powell, William S. *North Carolina Through Four Centuries*. Chapel Hill: University of North Carolina Press, 1989.

Powell, William S., and Jay Mazzocchi. *Encyclopedia of North Carolina*. Chapel Hill: University of North Carolina Press, 2006.

Ready, Milton. *The Tar Heel State: A History of North Carolina*. Columbia: University of South Carolina Press, 2005.

"The Reed Gold Mine." North Carolina Historic Sites. August 2014. www.nchistoricsites.org/reed/reed.htm.

Sanford, William R., and Carl R. Green. *Daniel Boone: Courageous Frontiersman*. Berkley Heights, NJ: Enslow Publishers, 2013.

Simon, Stephanie. "Billy Graham, Tourist Attraction." *Los Angeles Times*, May 28, 2007. http://articles.latimes.com/2007/may/28/nation/na-billy28.

"State and County Quick Facts: North Carolina." United States Census Bureau. January 2015. http://quickfacts.census.gov/qfd/states/37000.html.

Steelman, Ben. "Is Hugh McRae's Legacy to Tainted for Parks Name?" StarNews Online. November 2014. http://www.starnewsonline.com/article/20150711/ARTICLES/150709828.

Stevens, Hampton. "Why People Still Watch *The Andy Griffith Show*." *The Atlantic*, July 3, 2012. http://www.theatlantic.com/entertainment/archive/2012/07/why-people-still-watch-the-andy-griffith-show/259409.

"Textiles." North Carolina Business History. December 2014. http://www.historync.org/textiles.htm.

"Textiles and Apparel." North Carolina in the Global Economy. December 2014. http://www.ncglobaleconomy. com/textiles/overview.shtml.

"The Toll of Tobacco in North Carolina." Campaign for Tobacco-Free Kids. December 2014. https://www.tobacco freekids.org/facts_issues/toll_us/north_carolina.

Trotter, William R. *Bushwhackers: The Civil War in North Carolina*. Winston-Salem, NC: John F. Blair Publisher, 1988.

———. *Silk Flags and Cold Steel: The Piedmont*. Winston-Salem, NC: John F. Blair Publisher, 1988.

"University of North Carolina at Pembroke College Portrait." College Portraits. November 2014. http://www.collegeportraits.org/NC/UNCP/characteristics.

Waker, Grant. *America's Pastor*. Cambridge, MA: Harvard University Press, 2014.

Winer, Samantha. "A Brief History of Slavery in North Carolina." UNCG Digital Collections. October 2014. http://libcdm1.uncg.edu/cdm/history/collection/RAS.

Wormser, Richard. *The Rise and Fall of Jim Crow*. New York: St. Martin's Press, 2014.

Yannessa, Mary A. *Levi Coffin, Quaker: Breaking the Bonds of Slavery in Ohio and Indiana*. Philadelphia: Friends United Press, 2001.

Zinn, Howard, and Anthony Arnove. *Voices of A People's History of the United States*. New York: Seven Stories Press, 2004.

ABOUT THE AUTHOR

A former wilderness guide, college professor, camp director, park ranger, illustrator, furniture maker and home repairman, Ben Fortson was forced to finally give up on his heterogeneous career and just write about it. A consummate note taker and doodler, he has amalgamated years of seemingly random activity into a seemingly legitimate vocation: writing—and drawing—about life.

Ben writes and illustrates *Almost Off the Record*, a history comic with a humorous slant on historical events, and has published several books containing collections of his comics. He continues to write and illustrate history books, children's books and a random assemblage of witty stories. Currently residing in Black Mountain, North Carolina, with his wife and three children, Ben has explored his home state from top to bottom, finding it seething with fascinating characters, enchanting history, incredible scenery and great barbecue.

Visit us at
www.historypress.net
..
This title is also available as an e-book